BURTON UPON TRENT

THROUGH TIME

Arthur Roe &
Terry Garner

AMBERLEY PUBLISHING

With thanks to Glenys's Café for the refreshments

First published 2014

Amberley Publishing
The Hill, Stroud, Gloucestershire, GL5 4EP
www.amberley-books.com

Copyright © Arthur Roe & Terry Garner, 2014

The right of Arthur Roe & Terry Garner to be identified as
the Authors of this work has been asserted in accordance
with the Copyrights, Designs and Patents Act 1988.

ISBN 978 1 4456 1949 1 (print)
ISBN 978 1 4456 1967 5 (ebook)

British Library Cataloguing in Publication Data.
A catalogue record for this book is available from the
British Library.

Typesetting by Amberley Publishing.
Printed in Great Britain.

Introduction

Burton upon Trent is renowned for being one of the brewing capitals of the world. I believe it still is, despite the number of breweries that have sadly been amalgamated into others, or have ceased to exist. Marston's PLC is one of the remaining breweries still operating in Burton today. They brew the world-famous Pedigree ale and Bass draught under license from AB Inbev. Molston Coors, who have what is left of the Bass brewery, still brew Worthington beers. There are also several microbreweries that brew some of the country's best, award-winning beers.

Today, three shopping centres and housing developments stand on the vast former brewery sites of Bass, Allsopp's, Salts and Worthington. Large sites that once housed the gigantic malting buildings and cask storage areas for the breweries have now been turned into business parks comprising warehouses, small businesses, shops, hotels and fast-food outlets. Modern breweries of today do not require the large sites that they once did.

Burton is a vibrant, fast-growing town with miles of colourful Washlands river walks along the river Trent. These walks take you through the town to the award-winning Stapenhill gardens and walks filled with wildlife and, of course, our wonderful swans.

Arthur Edwin Roe

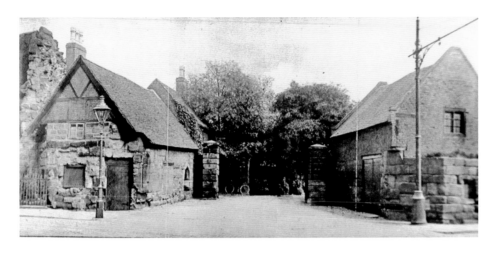

Burton Abbey Gateway

Having stood for centuries, the Gateway was demolished in 1927 for road widening and the building of the Abbey Arcade. Brass-angled plates marking the entrance, set into the tarmac, can still be seen. At one time, the right-hand building housed the horse-drawn fire engine.

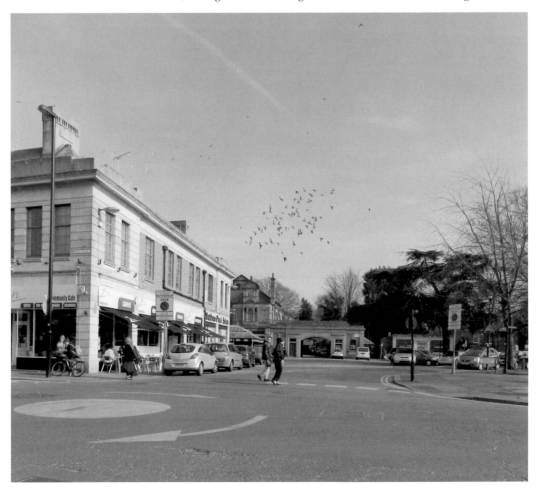

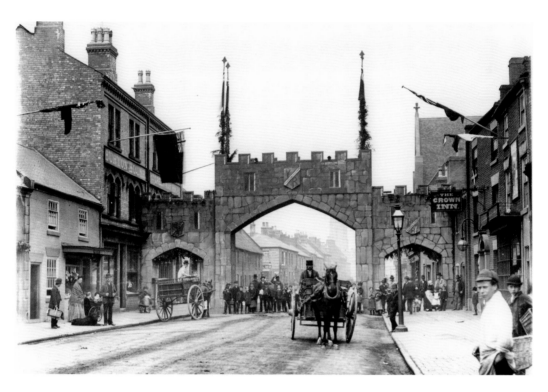

New Street Looking Towards the East

The buildings at this end of the street have hardly changed since this time. The arch, from 1897, was positioned roughly where the General Post Office was situated. The building just visible through the archway on the left is the location of Shaftesbury House, formerly the Burton Branch of the Working Men's Club, now housing the London Wireless Company. The church roof, just showing, was the New Street Baptist church that burnt down in 1966.

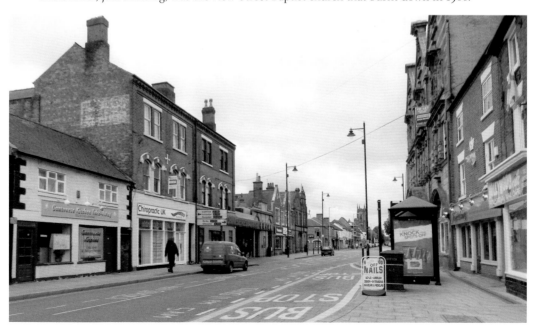

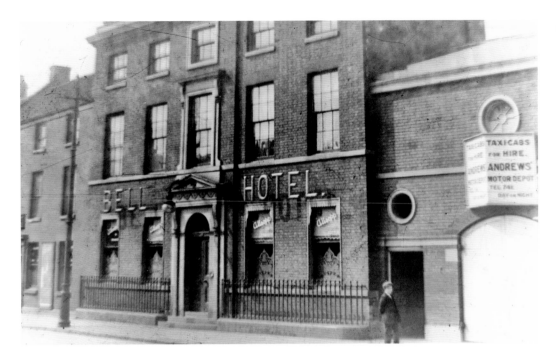

Bell Hotel, Horninglow Street

Formerly the town house of brewer Samual Allsopp, this building became the Bell Hotel for many years, and later the headquarters of the Territorial Army. Buildings to the right and to the rear were Allsopp's maltings and brewery. The smaller property, shown to the left and still standing, became the Bell Inn. It closed in the 1960s before becoming the Bell Hotel and, afterwards, apartments.

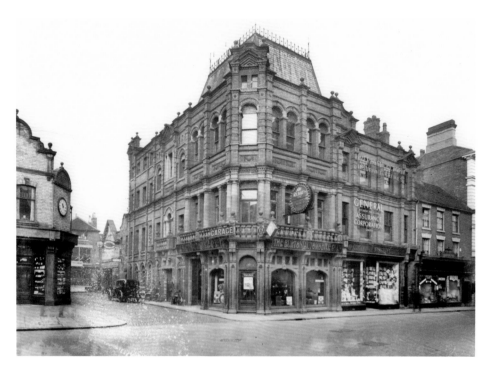

Bank Square/High Street

Present-day views of this area do not give any indication of what once stood here. Worthington's Jewellers stood to the left and the Burton Automobile building to the right, at the entrance of the ancient Bank Square that has long been demolished. Just visible to the right is Oakden's store and the White Hart Hotel.

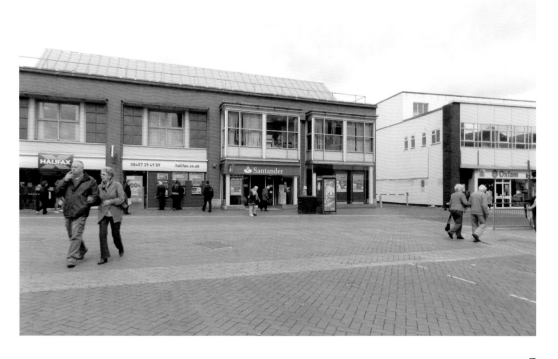

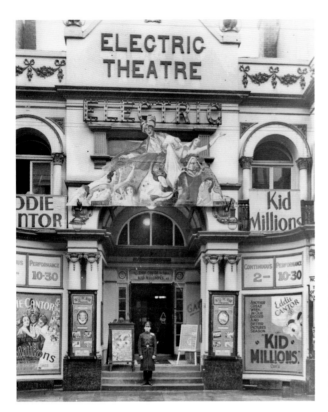

Electric Theatre, High Street
Apart from the ornate features, most of the upper part of this building still survives. The lower section, now an amusement arcade, was Broadmead's Electrical Store in the late 1950s and 1960s, which sold records and electrical white goods.

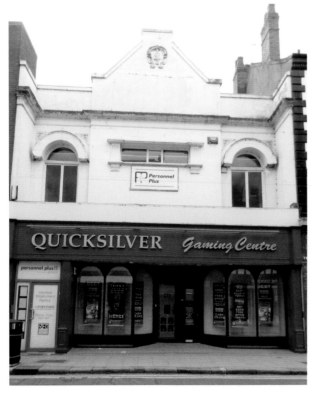

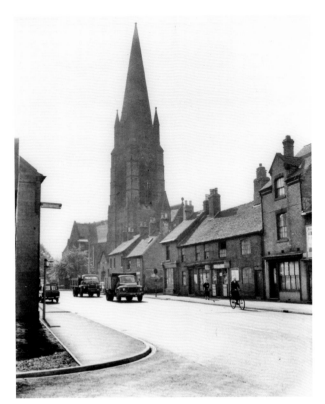

Horninglow Street
In the recent image, taken from outside the police station and law courts, no buildings on the far side of the street have survived. The Holy Trinity church, small cottages, the entrance to Marston's Brewery Maltings and the shops have all gone. Two supermarkets and Housing Association offices now stand on this location.

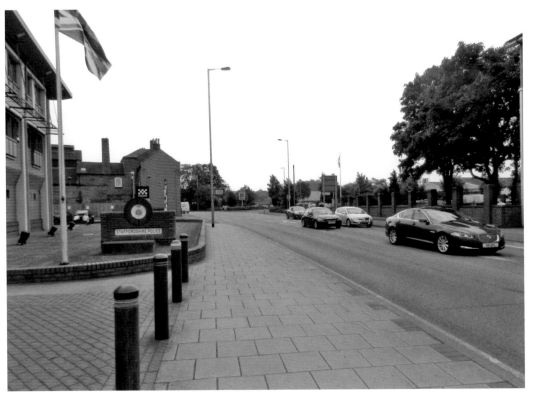

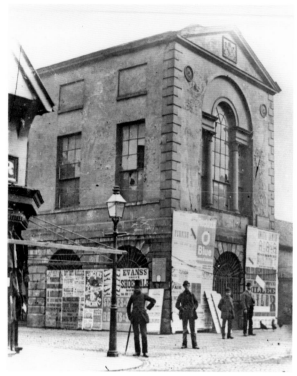

Entrance to the Market Place
Demolished in 1883, having stood
in situ for 111 years, the old market
hall made way for the new building
erected adjacent to the parish
church. The headstone is set into
the wall alongside the Andressey
Bridge, and angled markers set into
the block paving show the four
corners of the old building.

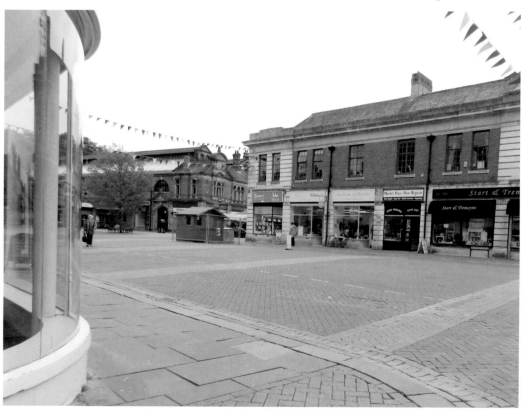

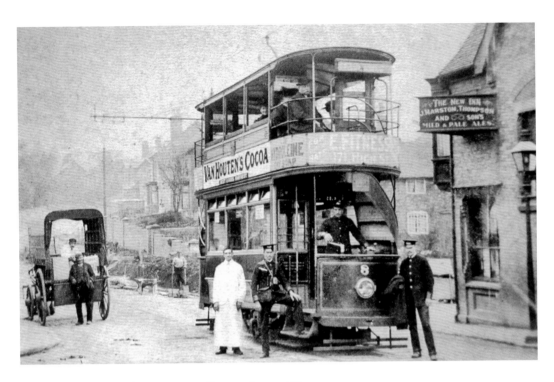

Main Street and Ferry Street Corner, Stapenhill

The terminus for the Corporation tramway system to Stapenhill lies in front of the New Inn public house. The inn still survives today and, apart from a change in business practice, the other properties have not altered either. At one time, a branch of Burton Co-operative Society stood behind the tram. It later became, among other things, a greengrocer's, florist's, carpet shop, and, at the time of writing, a betting office.

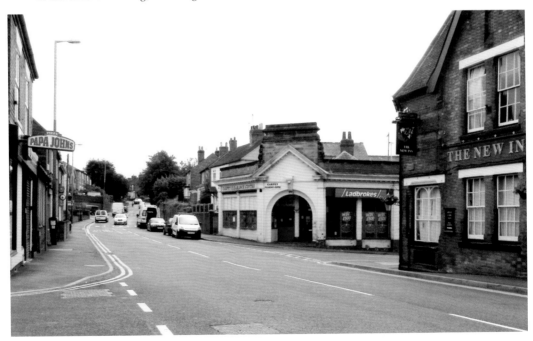

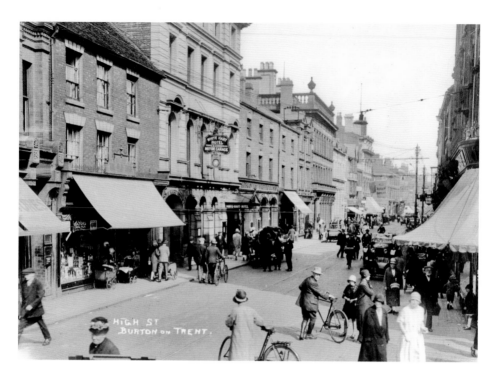

The High Street

Although difficult to recognise, this part of the High Street can be identified by (from right to left) the far building with the awning that is now a newsagent's, Oakden's, and the White Hart Hotel. All the buildings have since been demolished. A Specsavers optician's, now occupying the former site of Ellis's on the right, is also just visible.

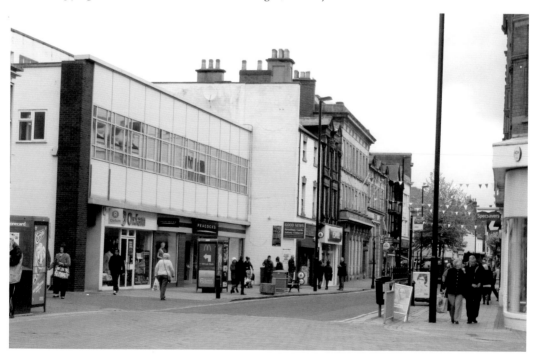

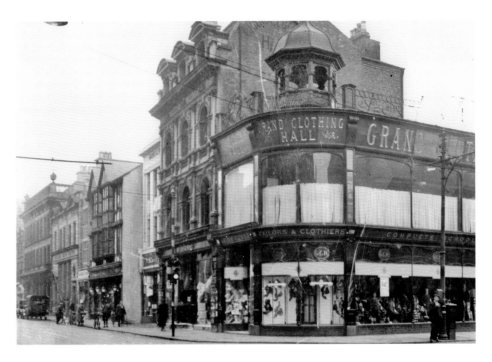

The High Street and Station Street Corner

This site originally held the Philadelphia Stores that made way for the Grand Clothing Hall in 1901. The premises later became a branch of Barclays Bank, until it moved further up High Street, and the building is currently a hairdresser's.

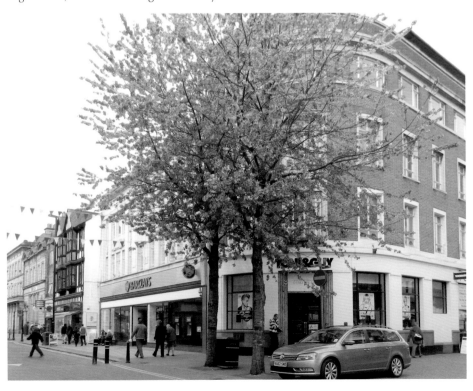

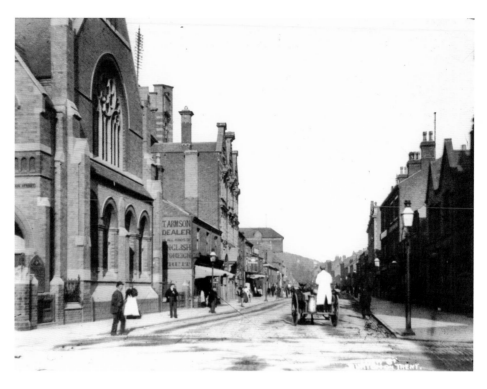

New Street and Union Street Corner

Looking towards the market place, the right-hand side of the road has barely altered since this picture was taken. As part of the regenerated central area, the left side has had the most redevelopment. The central building on the left, the old General Post Office, is the only one to have survived.

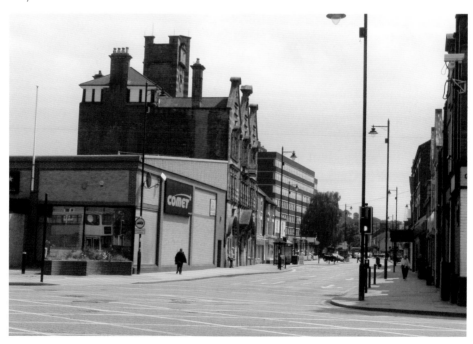

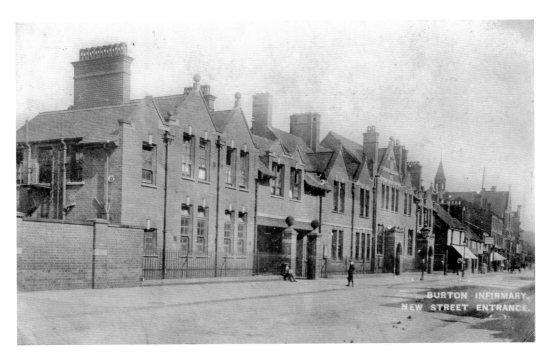

BURTON INFIRMARY.
NEW STREET ENTRANCE.

General Hospital, New Street

This was the front entrance of the hospital, which was demolished in the 1990s when all treatments were transferred to the Queen's Hospital on Belvedere Road. The whole area has been covered by a housing estate.

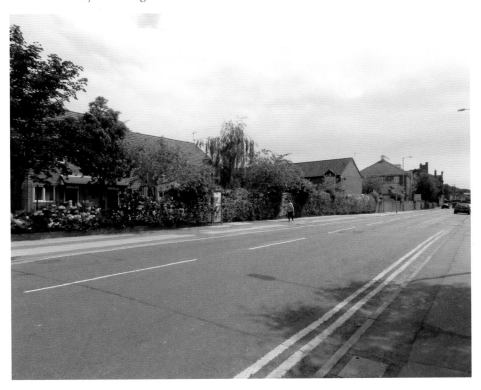

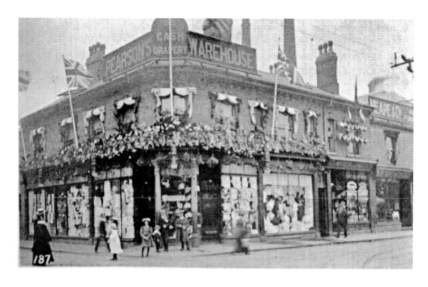

Pearson's

Originally shown here as Pearson's *Cash Drapery Warehouse*, the premises will be remembered by many people as Emery's General Stores. Following demolition, the corner plot was acquired by supermarket giant Sainsbury's.

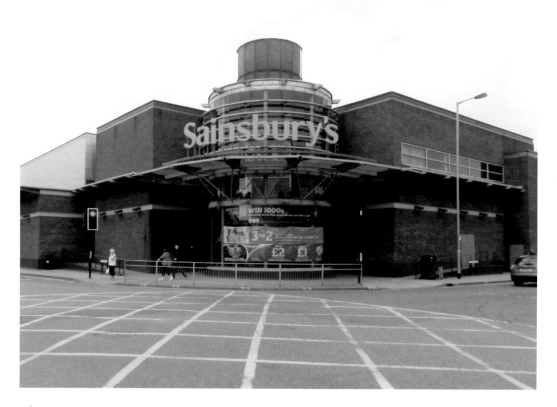

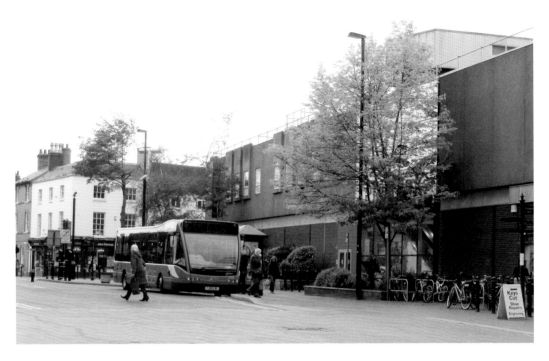

Bank Square

To the left of Bank Square and New Street corner stood Perk's grocer's, Burton Licence Victuallers, Mac fisheries and Sleigh's paper shop. Nos 1 and 2, on the corner, have been a car showroom, shoe shop, dry cleaners and cycle and radio dealers, before finally making way for the central redevelopment.

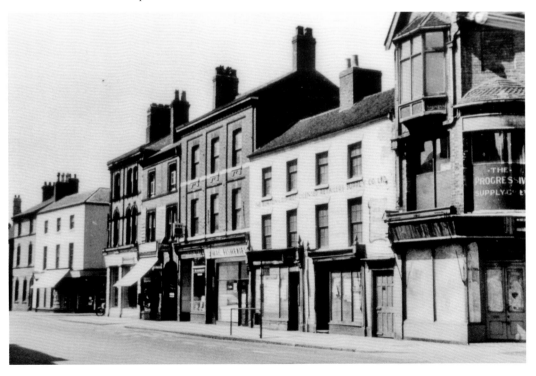

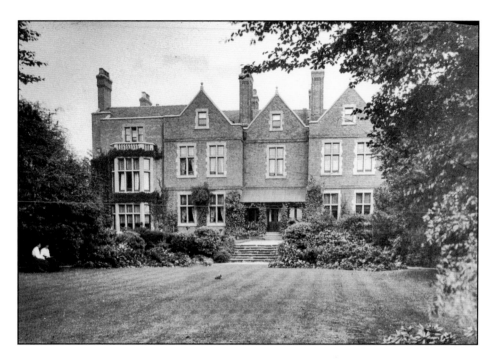

Stapenhill House

Until 1933, the magnificent Stapenhill House, at the time belonging to the Goodger family, stood on the banks of the River Trent close to Stapenhill church. As a result of crippling inheritance tax, the house was demolished and the land passed to Burton Corporation, who laid out the gardens as we know them today. The steps visible were the front entrance to the house, and are all that is left of this once impressive property.

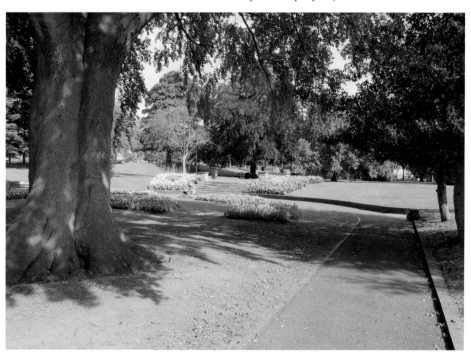

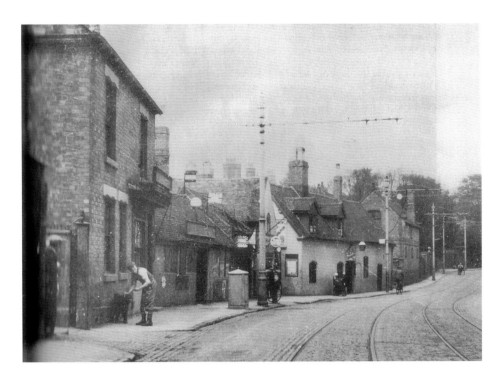

Main Street, Stapenhill

Taken at a time when trams still operated, a man stands outside Balls Butchers, now the only building still standing, with its slaughter house in the background. The old Punch Bowl Inn has long gone, and in the later picture the 'new' Punch Bowl has also been demolished. Between the butcher's and the public house stood one of Stapenhill's oldest blacksmith's.

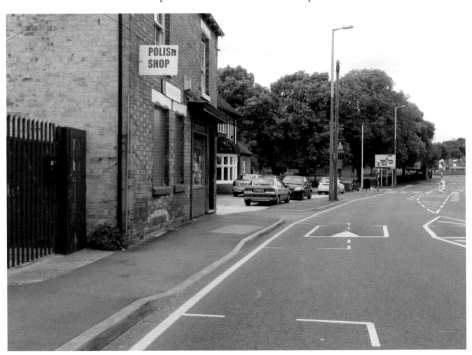

Bond Street and Green Street Corner

The house on the corner, still standing, lies opposite the former Bond Street Infants School buildings that were later used for musical instruction. A modern building, part of the Technical College complex, has replaced it.

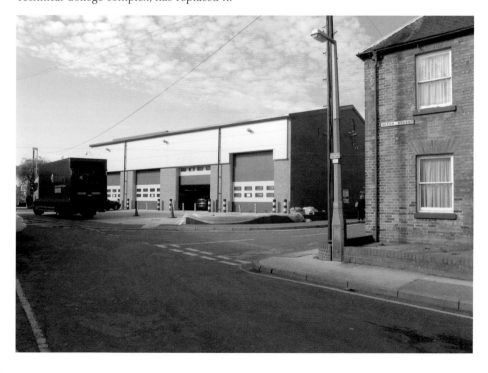

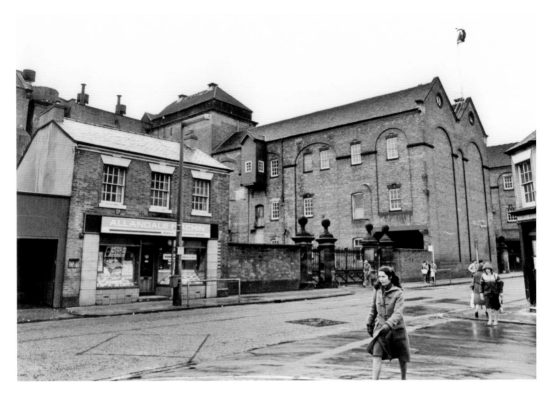

George Street and Station Street Corner

Just prior to removal, Alandale Machin estate agents and Bass New Brewery stand opposite George Street. The building on the right, now a chiropodist practice, was for many years Manloves independent bakery. Only one of the buildings on the left side of the road has survived, and the rest is now a Sainsbury's.

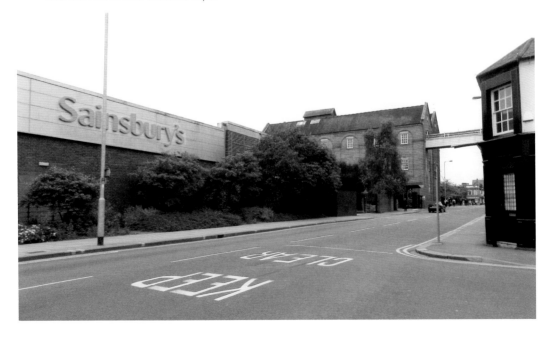

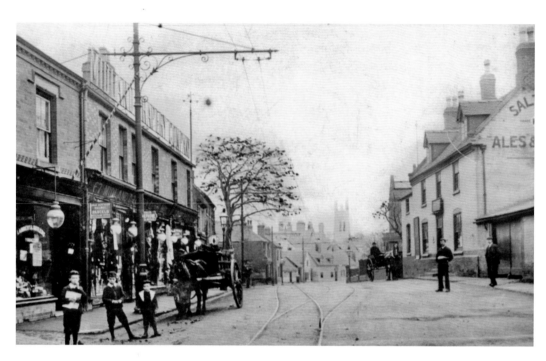

Main Street/Holly Street, Stapenhill

These buildings have barely altered in over a century. The Barley Mow, then under Salts' control, is now in Marston's hands and is known simply as The Barley. The Midland Drapery property is currently awaiting occupancy, its future uncertain.

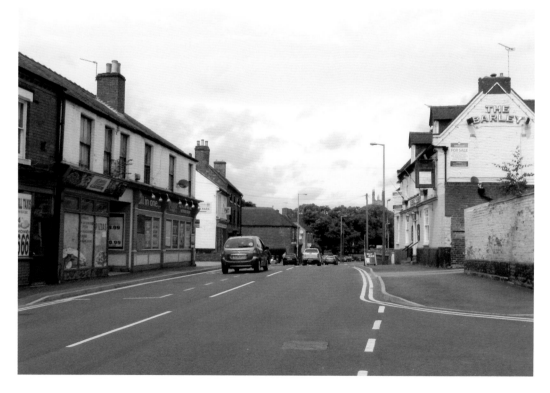

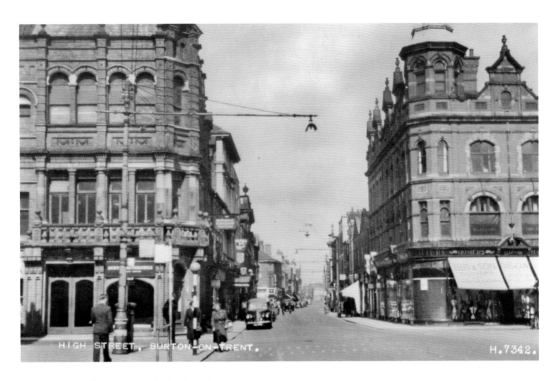

The High Street and Market Place

Looking north, the magnificent building on the left fell foul of developers in the 1960s. Ellis's corner building, erected in 1903, is still to be seen. The lower two floors are now used by a national optician's chain after the clothiers relocated to Station Street.

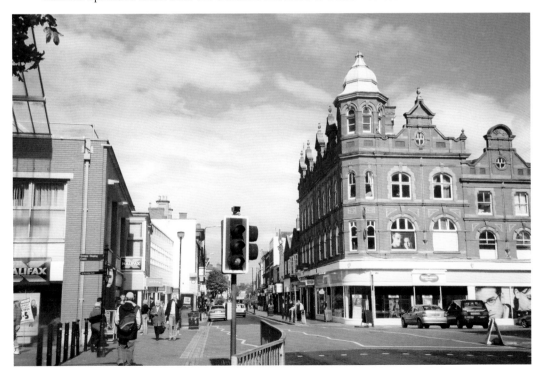

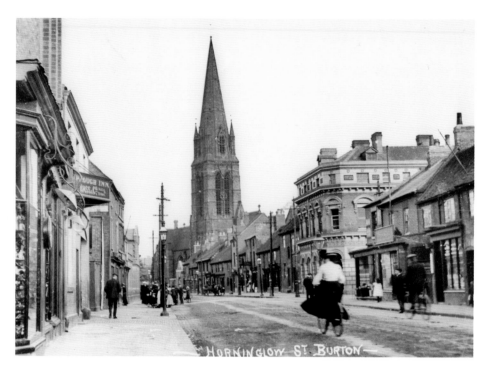

Horninglow Street and Guild Street Junction

Everything in this view has now disappeared, except for the buildings in the left foreground, which have been derelict for many years (the only easily identifiable one is the former Plough Inn). The large building on Guild Street corner has twice been demolished and rebuilt since the picture above was taken.

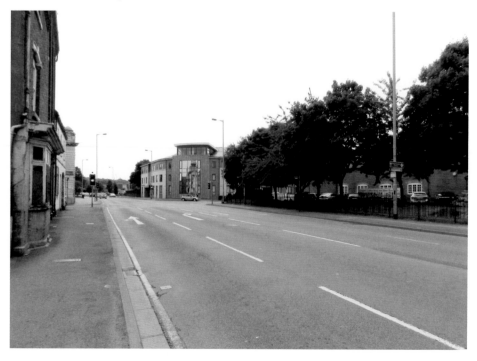

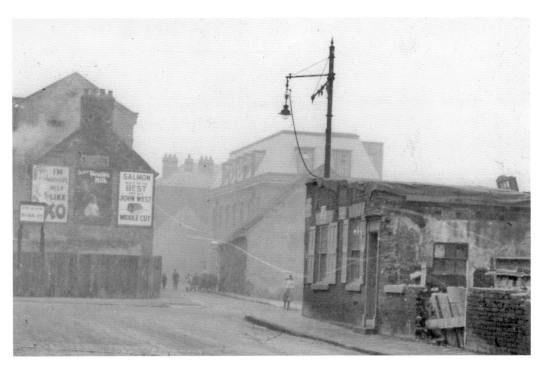

Fleet Street

Looking out from what is left of Park Street across to Fleet Street, one of the original telephone exchanges still stands, the five upper windows still visible. It is the only building to have survived the alterations to this part of the town in 1933.

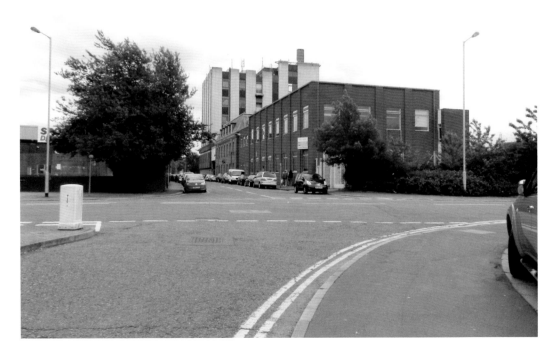

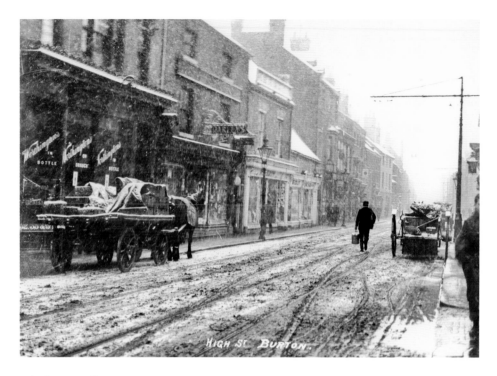

Brigdens Outfitters

Brigdens outfitters now occupies the building behind the lamp standard on the left of the photograph above. On this side of the road, Darley's Bookshop and the Albion Vaults public house are nothing but distant memories.

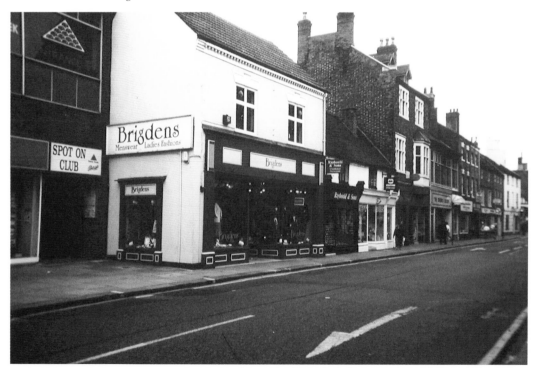

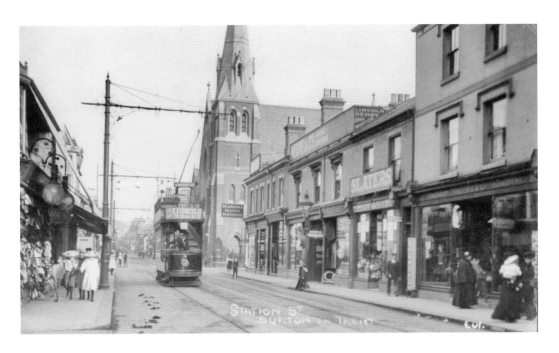

George Street

George Street corner, just visible in the bottom left, is all that remains from this more appealing view taken from the early twentieth century. The No. 1 tramcar, on its way into town, is bound for Winshill.

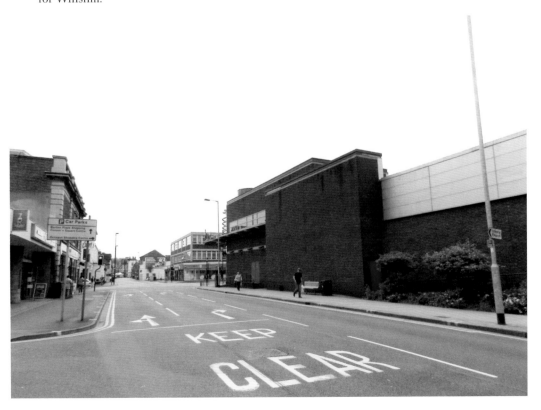

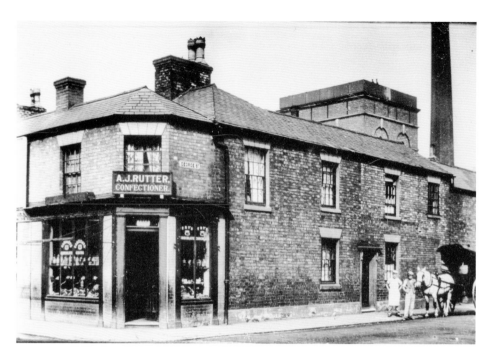

George Street/Station Street Corner

All the buildings on this side of George Street/Station Street corner have survived to this day. Rutter's confectioner's, which later became Manloves bakery, now houses a Chiropodist practice.

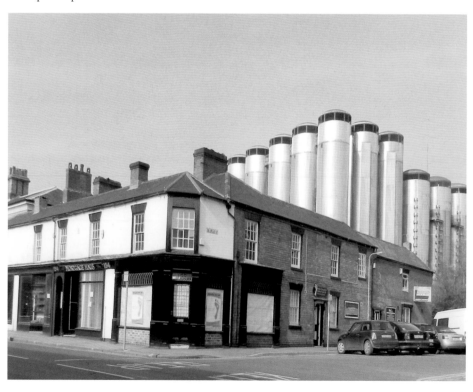

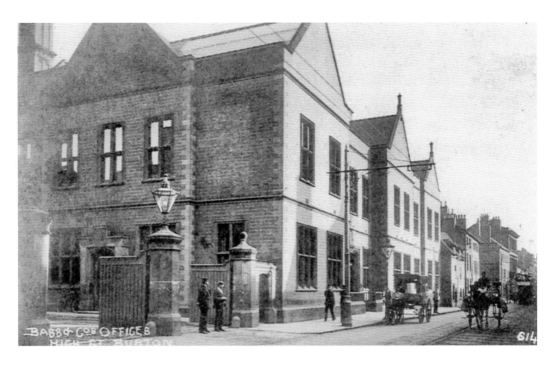

Bass Brewery

Bass Brewery offices in High Street have barely altered in over a hundred years; the only change to the original scene is the centre column of the entrance gateway, with the ornate lamp, which has been removed. Molson Coors UK now uses these premises as part of their headquarters.

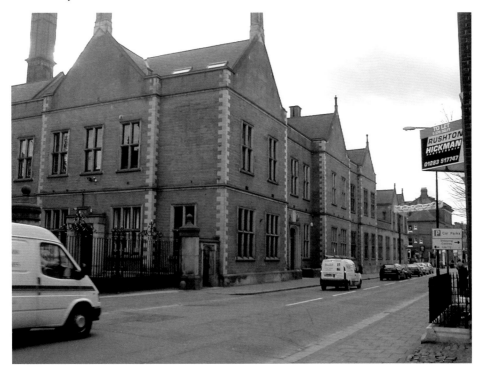

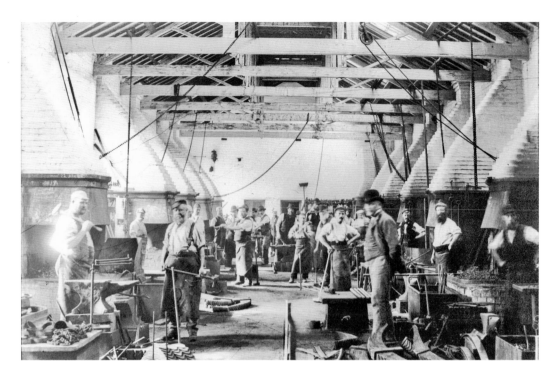

Bass Blacksmith's Shop
Twenty-two men – smiths and foremen – pose for the photographer in the early part of the twentieth century, taking a break from the tasks of making horseshoes, suspension springs for brewery vehicles, and other metal fittings. Today, this area forms part of the gallery of the National Brewery Centre.

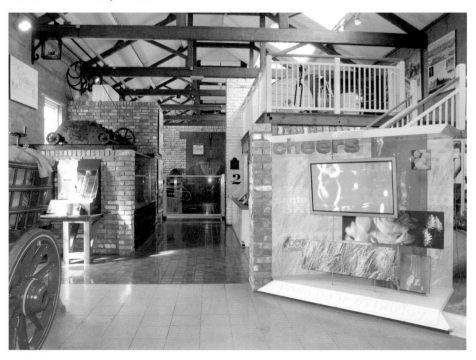

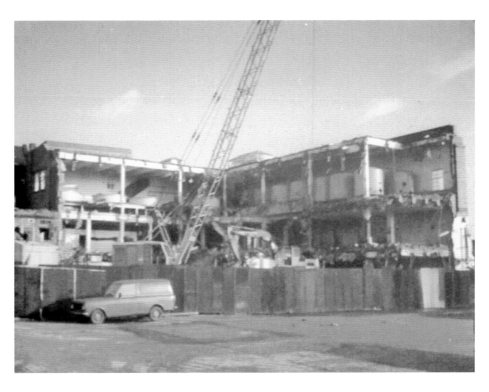

The Bass New Brewery
The site was cleared of all buildings in the 1980s and used as a car park. Today, it is still used for the same purpose by customers of Sainsbury's (at the far end, bordering Station Street).

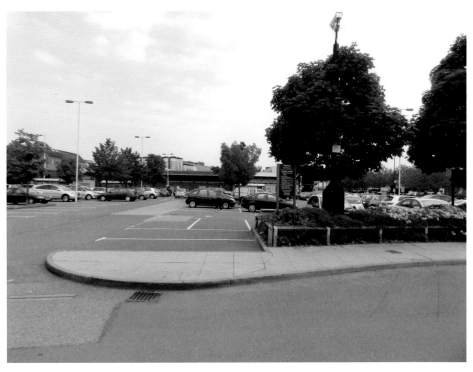

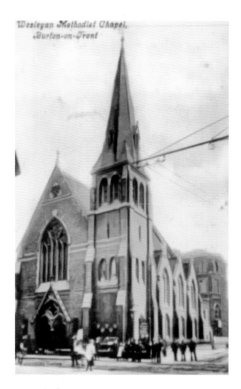

**The Wesleyan Chapel on Union Street/
Station Street Corner**
Built in just under two years at a cost of £4,000
(equivalent to £6 million today), the chapel lasted
from 1871 until it was demolished in 1958 and
replaced by a more modern structure.

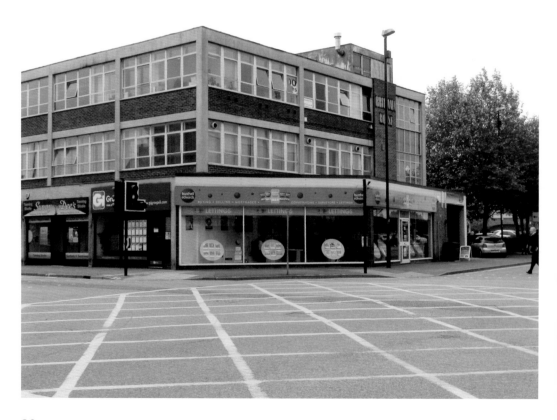

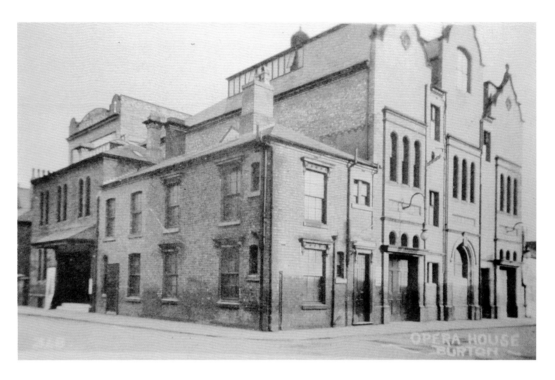

The Opera House, George Street
The only part still standing was part of the front entrance. The rear of the building, facing Guild Street, became the front entrance to the Ritz Cinema, which opened on 11 March 1935. The whole block replaced the original St George's Hall from 1887.

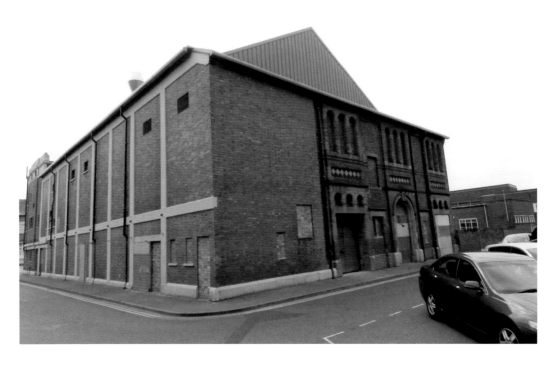

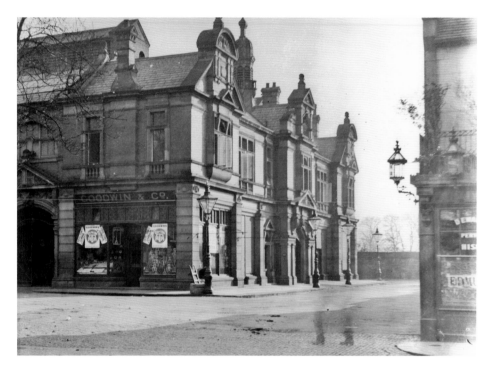

The Market Hall

Shown in 1883, when it was relatively new, the Market Hall stands opposite the Man in the Moon public house (to the right), which disappeared in the 1930s to be replaced by the Abbey Arcade. In the later shot, the refurbishment is about to begin and the outer stalls have already gone, having been in situ for over eighty years.

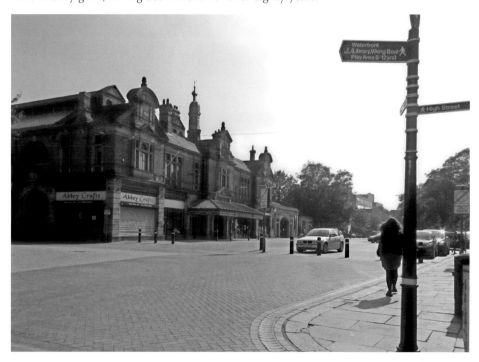

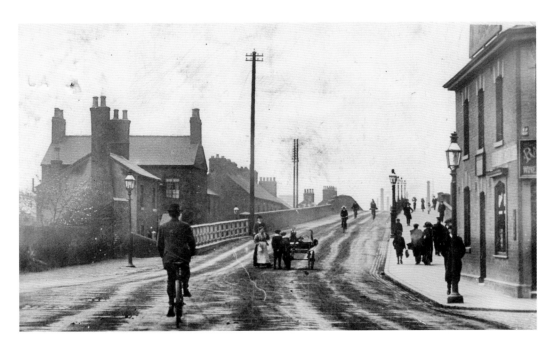

Little Burton Bridge

Little Burton Bridge, leading into town. While the large house to the left still survives, the small cottage attached to its front and the row to its right (left of the bridge) have all been removed. The Railway Bridge public house has also disappeared. As one of the main routes into town, this ancient junction is always very busy.

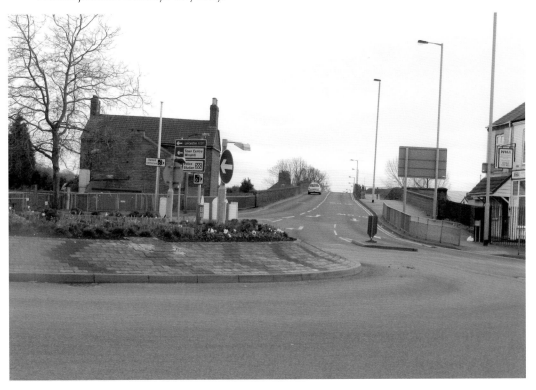

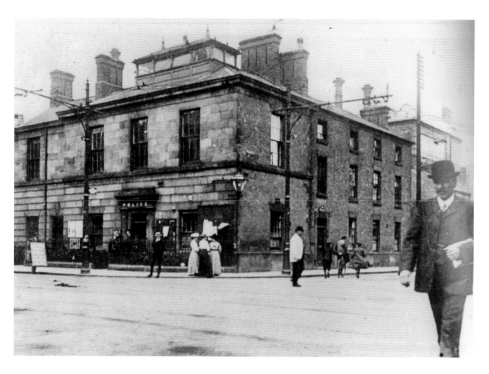

Museum and Art Gallery

Demolished in 1910, the first custom-built police station made way for the building of the Museum and Art Gallery in 1915. The upper floor housed artefacts, while the lower part was, for many years, used by the Gas and Electric Showrooms. Various businesses now occupy the premises.

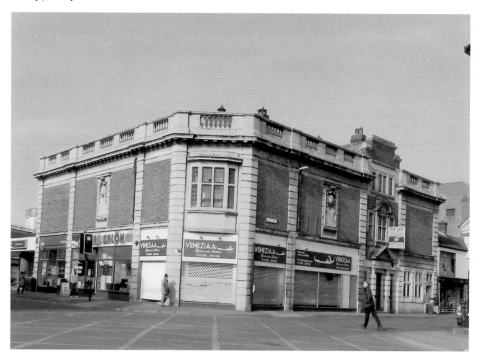

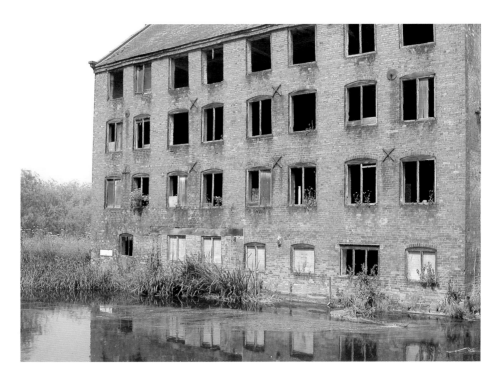

Greensmith's Flour Mill

Greensmith's Flour Mill on Newton Road dated back to Anglo-Saxon times, although it closed down in the 1990s after falling foul of modern milling practices. The large building shown above was Peel's Mill, which has now been converted into apartments. Other dwellings have been erected on parts of the site.

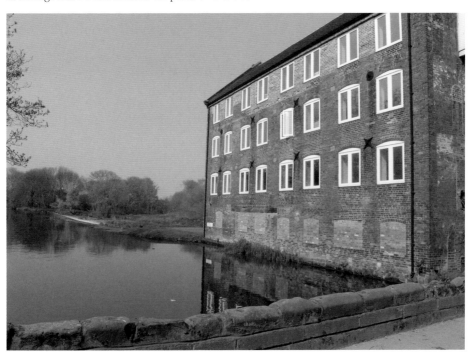

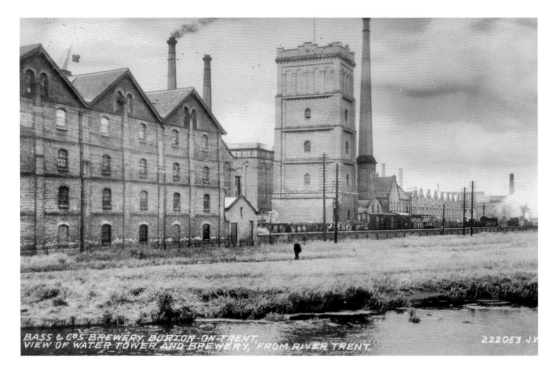

BASS & Cº'S BREWERY, BURTON-ON-TRENT,
VIEW OF WATER TOWER AND BREWERY, FROM RIVER TRENT. 222053.J.V

Old Bass Brewery

Looking back from the Washlands, the rear of the Old Bass Brewery water tower is all that remains from the vast array of brewery buildings that dominated this part of Burton. The library was built here in 1976, on the site of what was formerly Worthington's Maltings. It replaced the old library in Union Street.

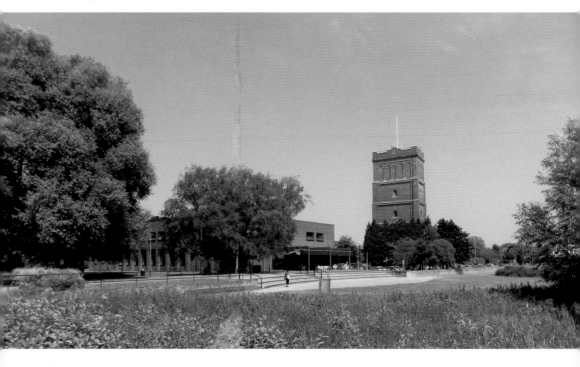

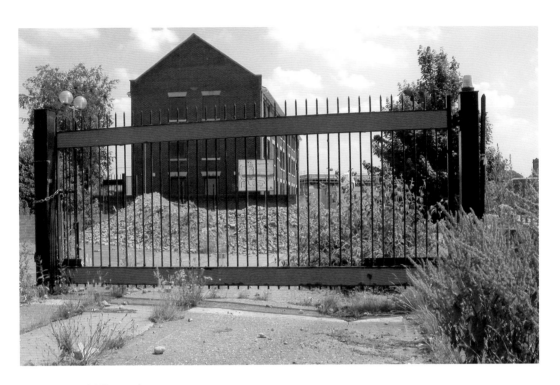

Bass Middle Yard

The Bass Middle Yard entrance is off Guild Street, and the large building, in Horninglow Street, houses the Trent & Dove Housing Association. The Middle Yard site, now renamed Middleway Retail Park, contains a bingo hall, cinema, shops and food outlets. The gateway has completely vanished.

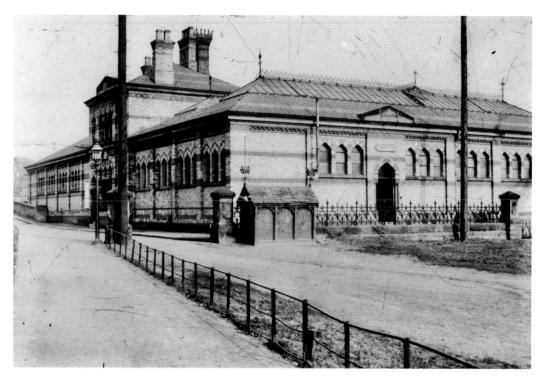

The Baths
Built in the early 1870s, the baths served the people of Burton until they closed in 1980 and were demolished. Swimming facilities were transferred to the new Meadowside Centre. The main pool outline, traced into the grass, can still be seen today. The base of the right-hand gate column in the early picture is still standing.

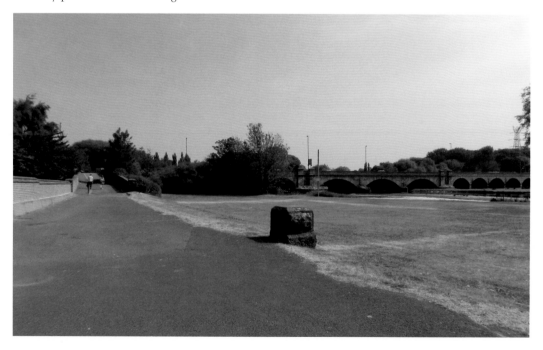

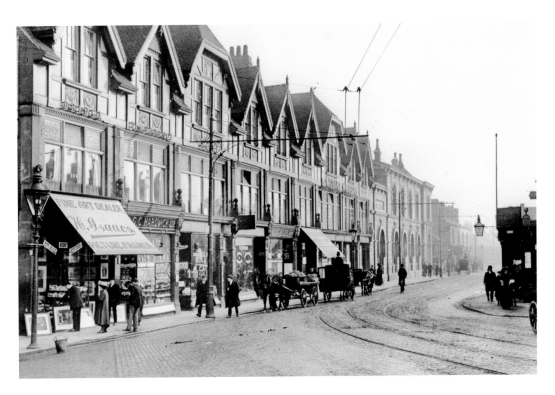

Midland Chambers

Midland Chambers, located at the foot of the Station Bridge at the west end of the street, has altered little over the years, except for the businesses. The Roebuck public house still occupies the same position but stands further back in the later shot.

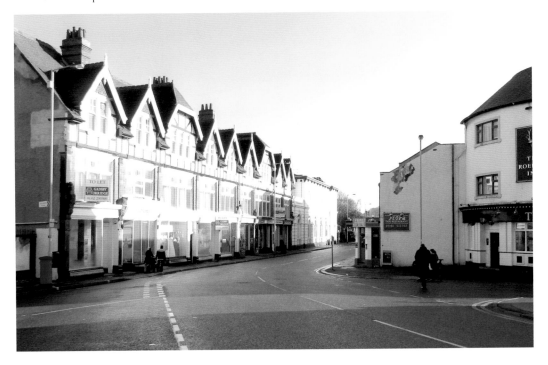

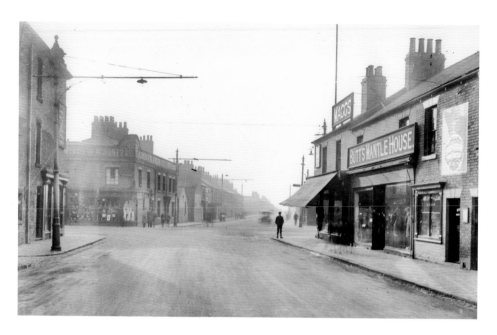

Butts Corner

Wellington Street/Borough Road corner, originally known as Butts Corner, has had quite a few changes to the way the traffic is controlled over the years. After the demolition of Butt's store, the extension to the town hall was erected. At the time of writing, this building stands empty and is up for sale, the staff having been moved to Wetmore Road.

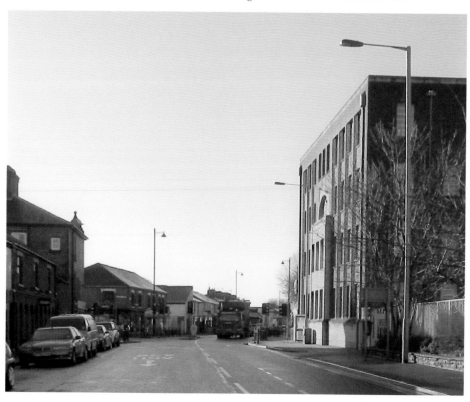

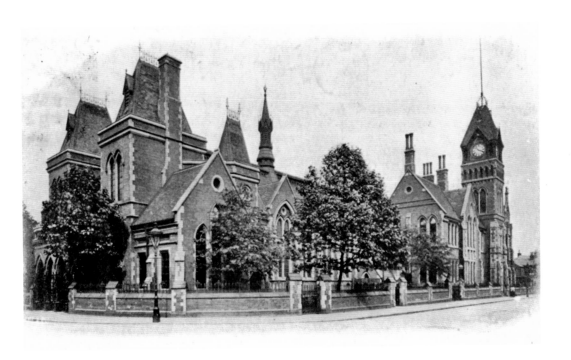

Town Hall

This building, intended as the town hall, was bestowed as a gift to the town by Michael Arthur Bass in 1891, together with the now demolished St Paul's Institute. The original entrance doorways are still to be found in Rangemore Street, although the high elevations above them were removed many years ago.

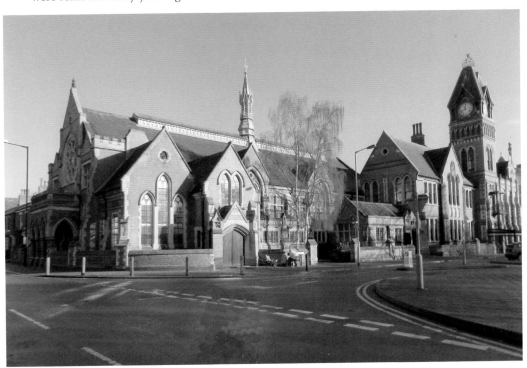

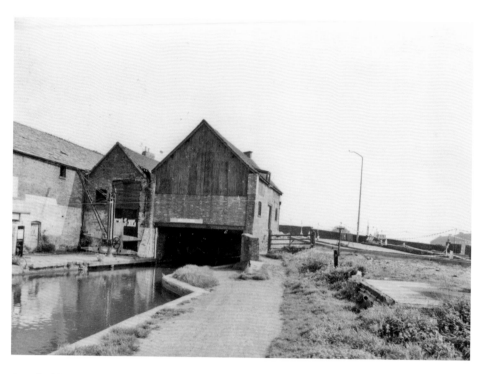

Canal Side, Horninglow Basin
The impressive North Staffordshire Railway salt warehouse, spanning the canal, made way for the new road bridge and road improvements when the old bridge was deemed inadequate for modern traffic in 1977.

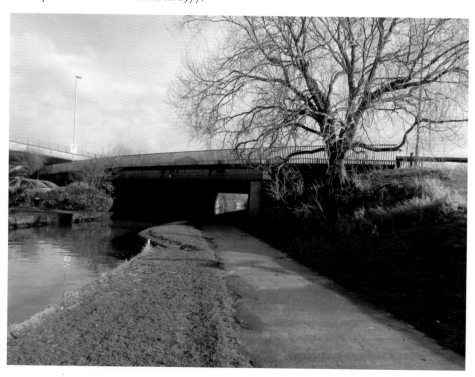

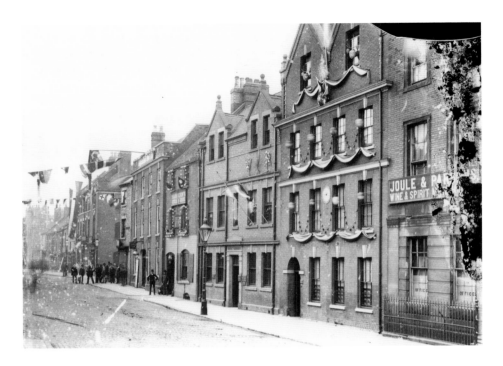

Bridge Street Junction

The junction linking Bridge Street, Horninglow Street and Wetmore Road has hardly changed over the years. The shop on Wetmore Road corner, where the group of men are standing, was removed in 1903 for the introduction of the tramway system. The building showing The Three Queens sign, second from the right, has had the top apex removed and a top storey added.

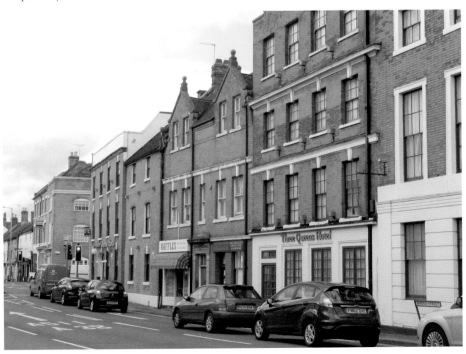

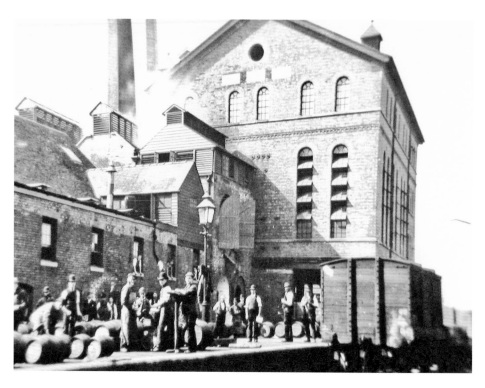

Worthington Way
Looking into Worthington Way from High Street, all the buildings of the old Worthington Brewery have been demolished and Burton Place shopping centre covers the entire site.

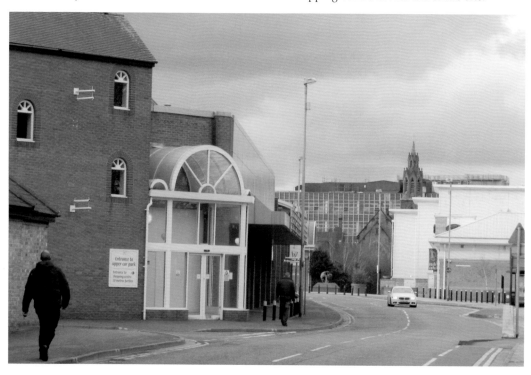

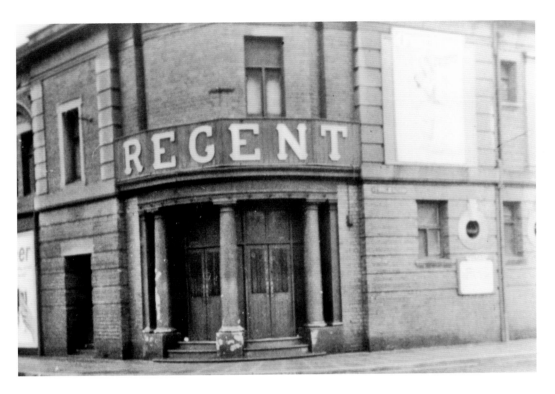

Regent Cinema

A patch of waste ground is all that remains at the former site of the Regent Cinema (once one of Burton's three picture houses). The site had also housed church meetings and the Crown Bingo Hall before it burnt down in 2008.

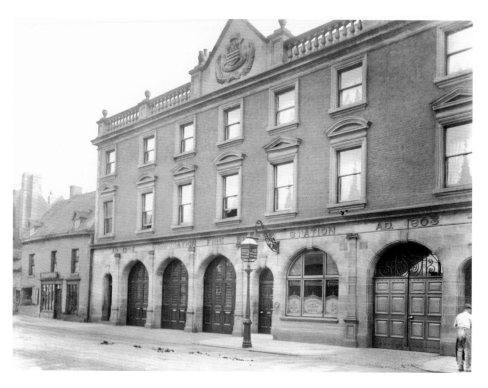

Fire Station

Built in 1903, this was Burton's main fire station for many years until services were transferred to the new station further along Moor Street in mid-1970s. The magnificent frontage can still be seen, with the lower part now a car showroom.

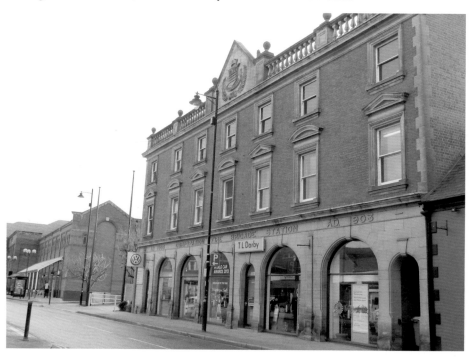

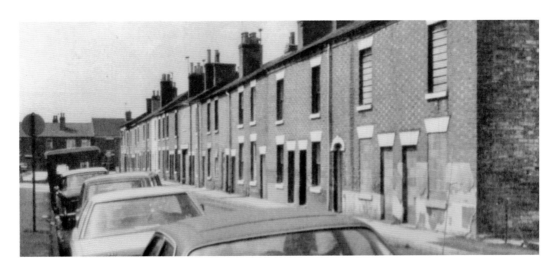

Milton Street

Terraced houses in Milton Street were demolished in the 1980s to make way for the modern buildings in the later photograph.

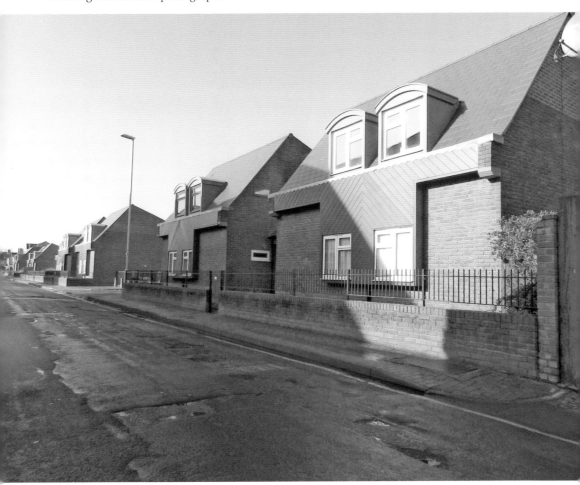

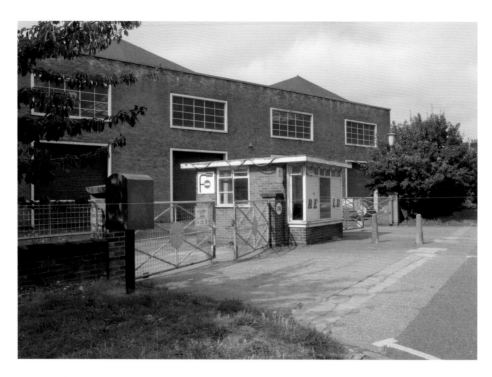

Renold Chain

Renold Chain's main entrance is shown above shortly before complete demolition, the run-in off the road just visible. The ground was sold off in 2008 and the area is now completely covered by a housing estate.

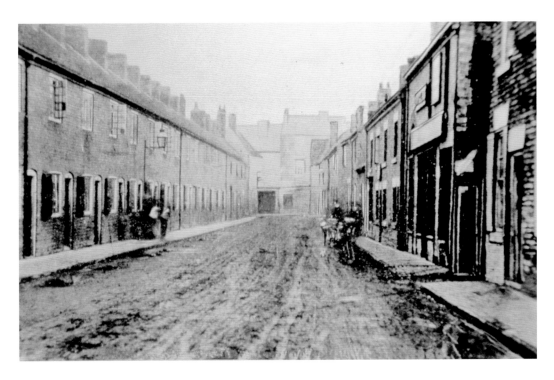

Station Street/High Street Junction
The mud-covered junction of Station Street/High Street in 1860 is transformed in the present-day image. Shops and businesses have replaced all traces of the old cottages.

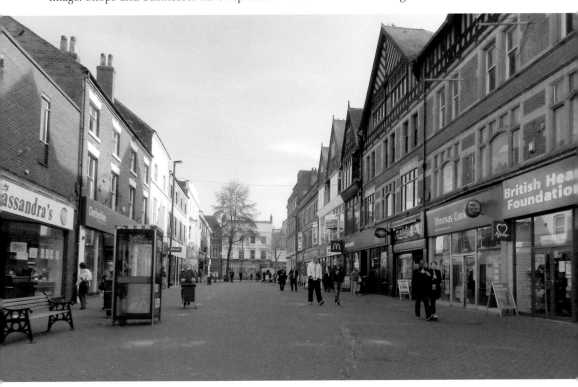

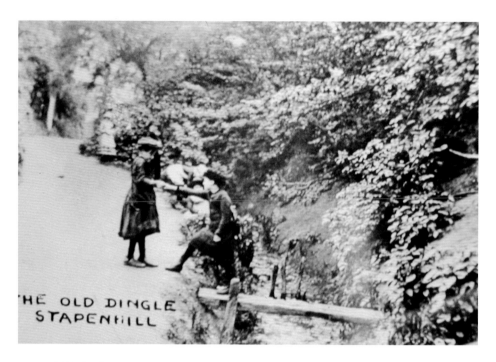

THE OLD DINGLE
STAPENHILL

Stapenhill Dingle

For many years, this was the view leading down to the Ferry Bridge crossing. The brook is now piped under the roadway to the right (in the modern picture), allowing access to the properties built on this side.

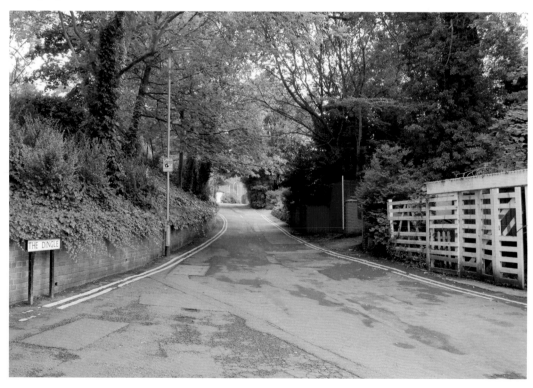

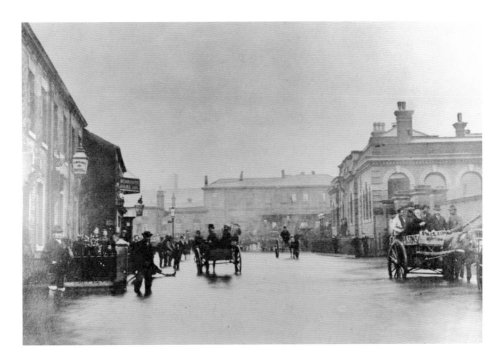

Former Railway Station

A dramatic shot, looking towards the former railway station, shows the 1875 floods at the foot of what is now the Station Bridge. Allsopp's brewery (now No. 107 Station Street) stands to the right. The old Roebuck Inn (sign visible on the left) was rebuilt further back from the pavement in the 1950s.

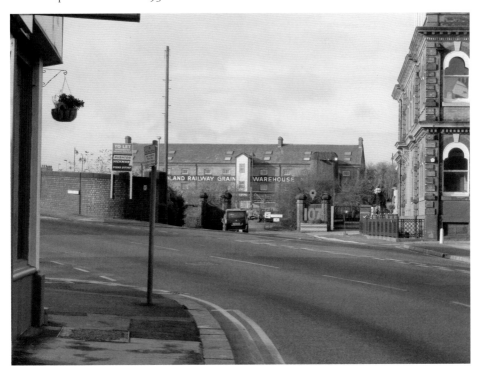

Nurses' Home

The nurses' home in Union Street provided accommodation for staff working at the nearby General Hospital, until they were all transferred to the new facilities at Burton District Hospital on Belvedere Road in the mid-1990s. The building suffered some damage when the Baptist chapel opposite burnt down in 1966. Housing Association properties now stand on the nursing home ground, and a retail unit has been built on the church site.

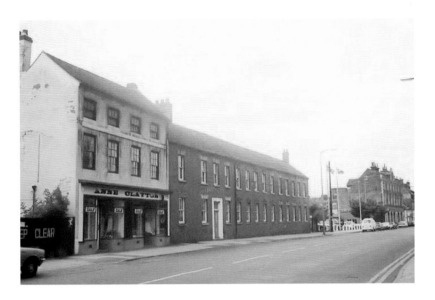

The Octagon

The Octagon Shopping Centre now stands on the area that was once occupied by Ann Cayton's clothes shop and Briggs Engineering Works. The gateway (marked 'CLEAR') was where the New Street No. 2 railway crossing traversed the road.

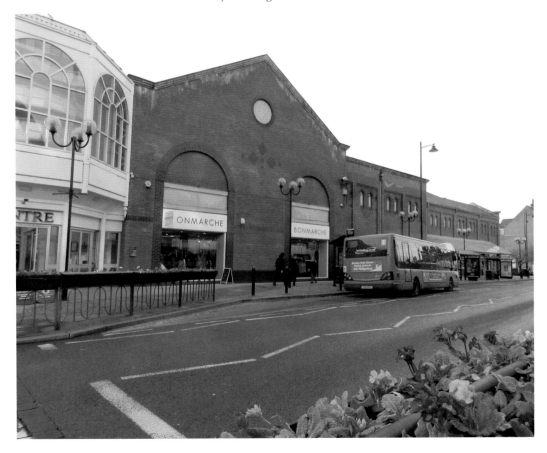

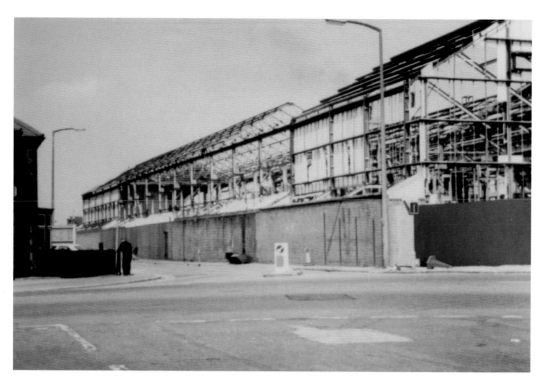

Briggs

In a view from Lichfield Street, rear buildings of Briggs are being demolished in Park Street in the mid-1980s. The road ran through to Orchard Street, then on to the Union Street/New Street junction lights. The Octagon delivery bays and rear entrance are to the right.

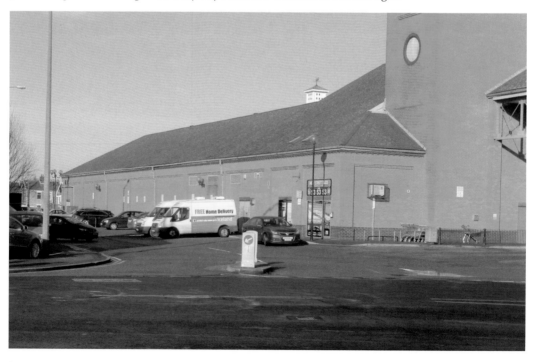

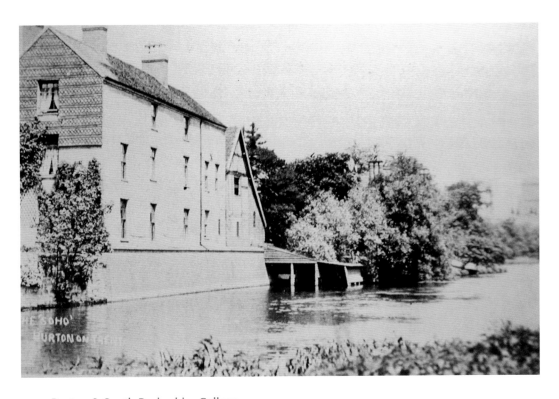

Burton & South Derbyshire College

Perhaps not familiar to many, the rear end of Burton & South Derbyshire College was once known as the Soho Wharf, where goods were loaded onto sail barges to be shipped downriver to Hull. Part of the wharf wall is just visible through the undergrowth.

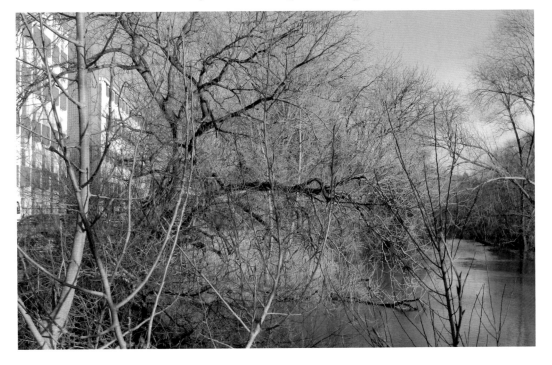

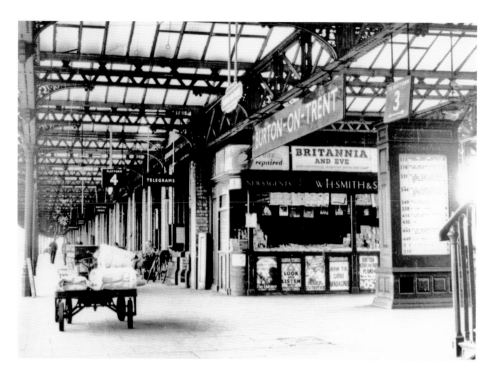

Burton Railway Station

The modern-day platform of Burton railway station bears no resemblance to the magnificent Victorian buildings that were once a feature of the station; the steps down to the platform are all that remain. A WHSmith bookstand, together with the rail timetable indicator board and refreshment room, have all gone.

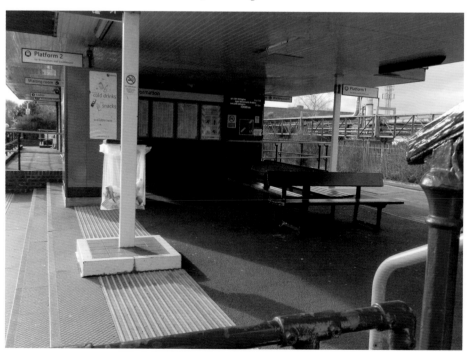

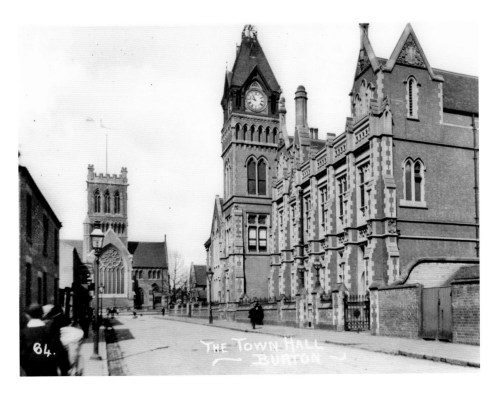

King Edward Place

King Edward Place, the Liberal Club property that is now the town hall, and St Paul's Street East are still to be seen. Shrubbery has now replaced the buildings, and the roadway has been widened to allow car parking close to the statue of Lord Burton, erected in 1911.

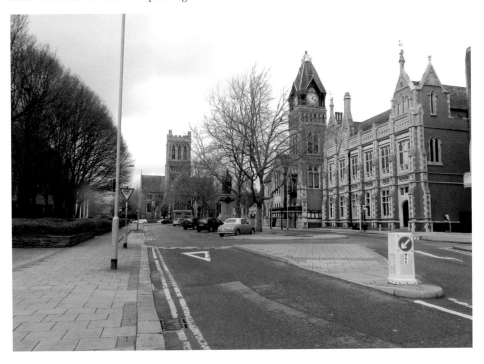

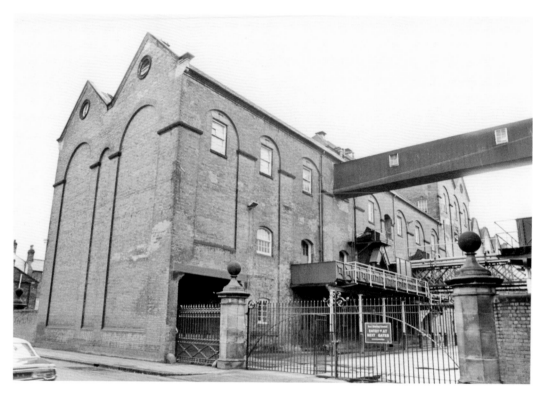

Bass New Brewery, Station Street
This building has been removed to make way for the present-day delivery bays of Sainsbury's. The ornate stone gate pillars have been demolished and replaced by featureless steel ones.

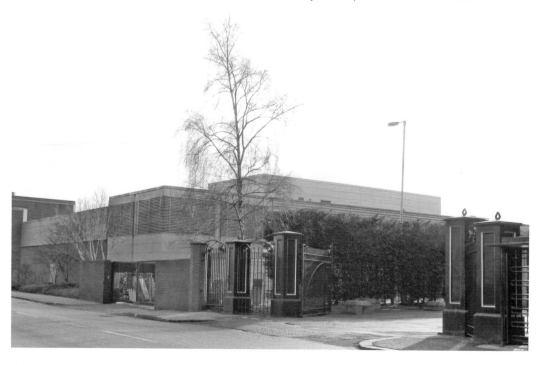

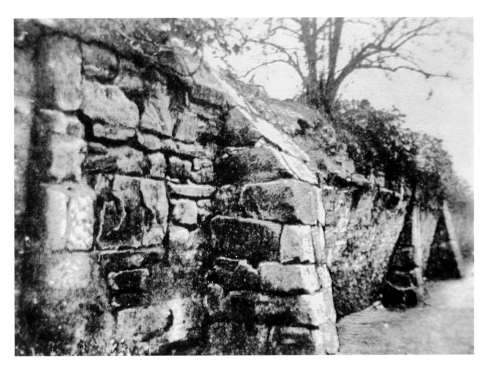

Friars Walk

Friars Walk wall, part of the ancient Burton Abbey site, is all that remains today from the time when monks would pass this way en route to St Modwen's Island and their fish stock pond. Behind this wall, now lower, are the memorial stones put in place in the 1950s when the garden of remembrance was laid out.

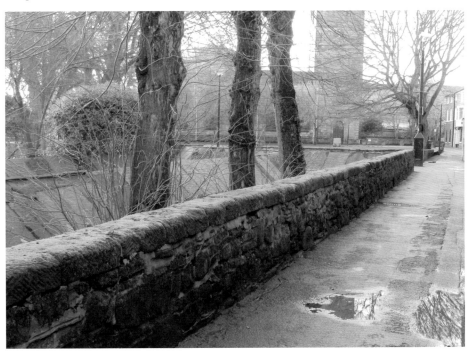

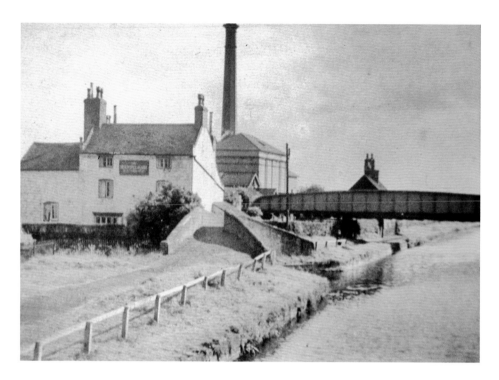

The Mount Pleasant

The Mount Pleasant public house (known locally as Bessie Bulls after the landlady) stood next to the canal junction at Shobnall of Trent & Mersey Canal and the Bond End Canal for many years. The pedestrian-access bridge is still used to access the canal towpath. The Marston rail crossing has now been reduced to a single-side span purely used for advertising purposes.

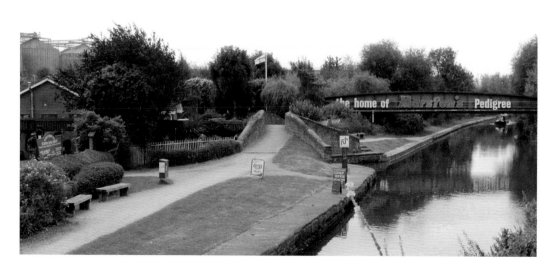

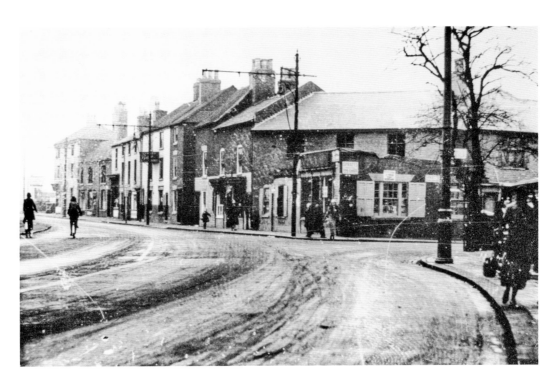

Peel Croft

From Lichfield Street/Park Street corner looking towards Peel Croft, the only surviving property in view still standing is the first corner shop (Frost's electrical store for many years). Cottages and the New Inn public house alongside did not survive the redevelopment that took place over fifty years ago.

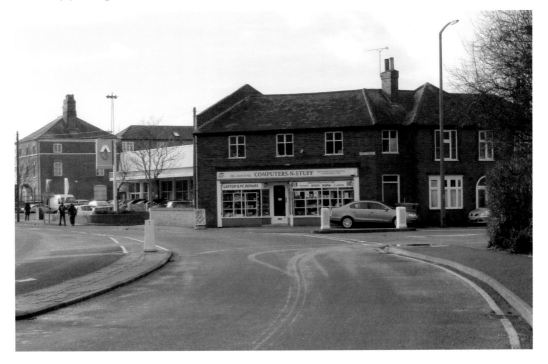

Burton Nursing Institution

In the older picture, the Burton Nursing Institution, later housing the Maternity Home, stood at the junction of Duke Street and Union Street. It is now part of the Brewhouse car park, and Duke Street is now a no through way.

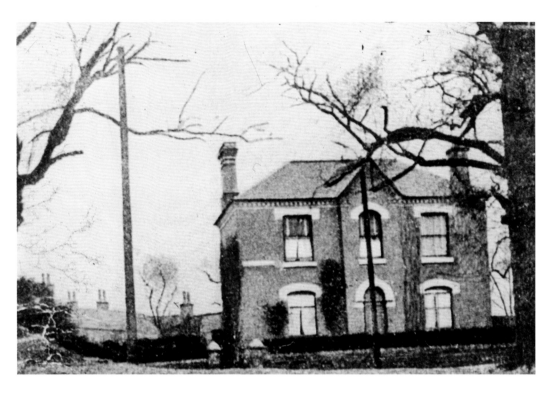

St Peters Street
Turning into St Peters Street, off Stapenhill Road, the large house opposite the war memorial has seen many changes since the above picture was taken.

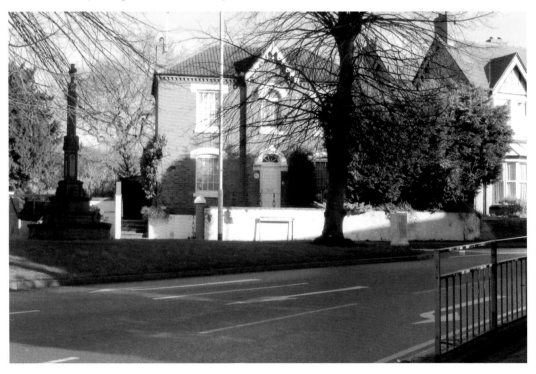

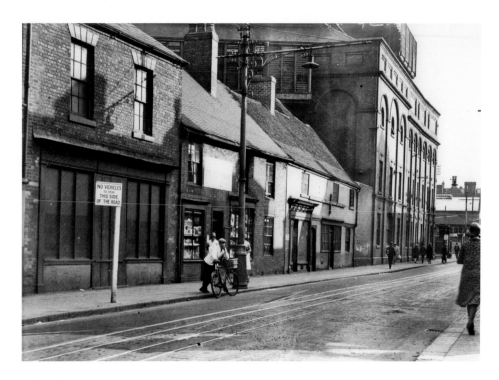

Allsopp's Brewery
Allsopp's huge lager brewery, along with shops and other premises leading down towards
Bass Town House, were removed for the building of the Bargates precinct. The precinct was
later demolished and is now open space.

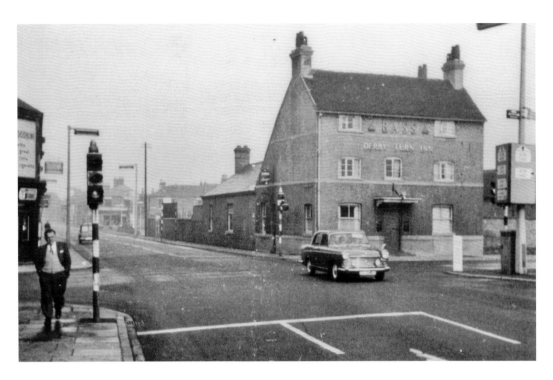

The Derby Turn

The Derby Turn public house in the picture above was demolished in 1964 and replaced with a new pub set further back to accommodate the road widening of the junction. This has also closed and been replaced by two shops.

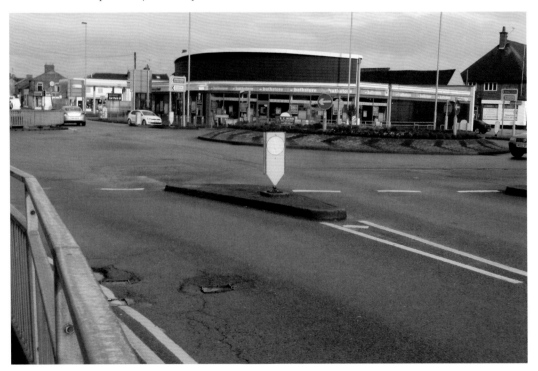

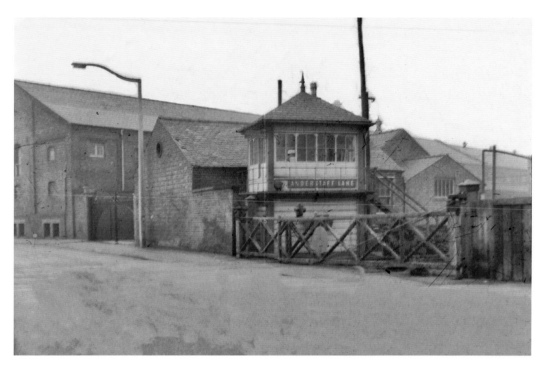

The Malting

The Malting building, the only malthouse that stood directly on Wetmore Road adjacent to Anderstaff level crossing, is now the headquarters of East Staffordshire Borough Council. The signal box and line are long gone.

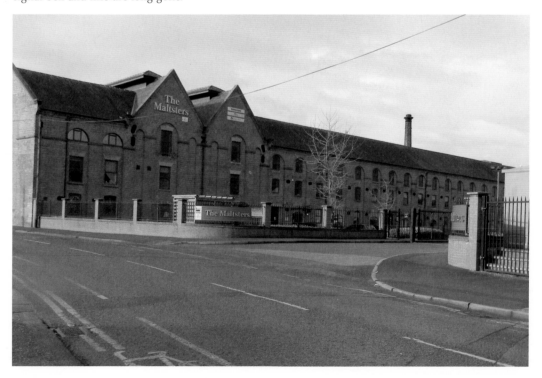

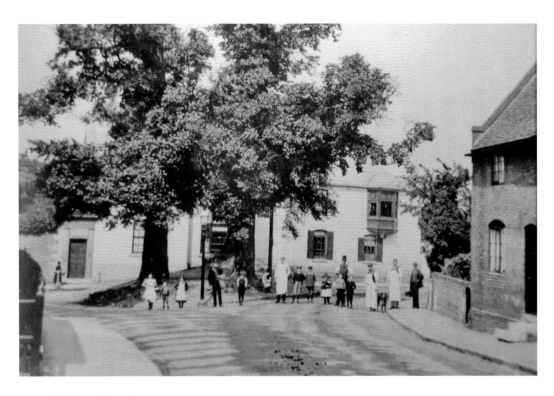

St Peters Street

St Peters Street, leading towards the access to the second river crossing (St Peters Bridge), now carries an enormous amount of traffic that was not present when the first photograph was taken.

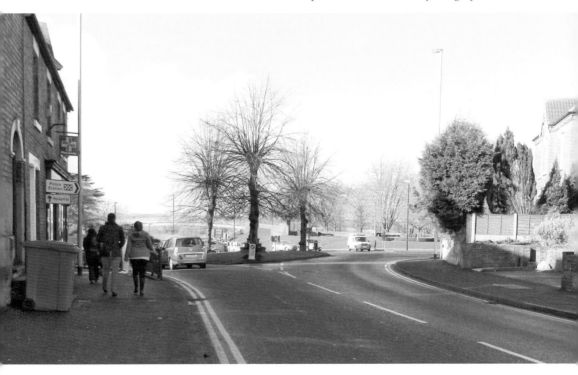

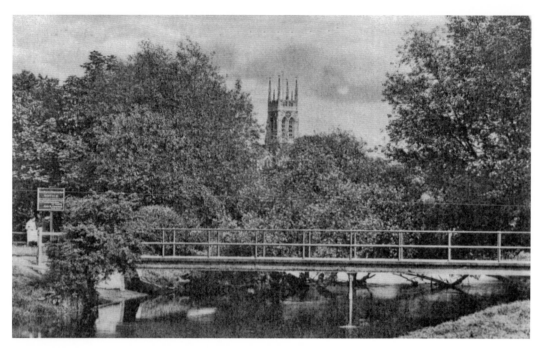

Footbridge

The footbridge that leads from the Ox Hay to the Stapenhill Viaduct, via the Silver Way branch of the River Trent, has been modernised several times over the years. Trees have been planted in the surrounding washlands to improve the appearance.

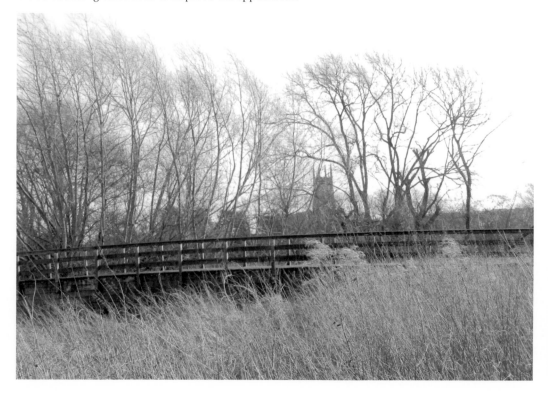

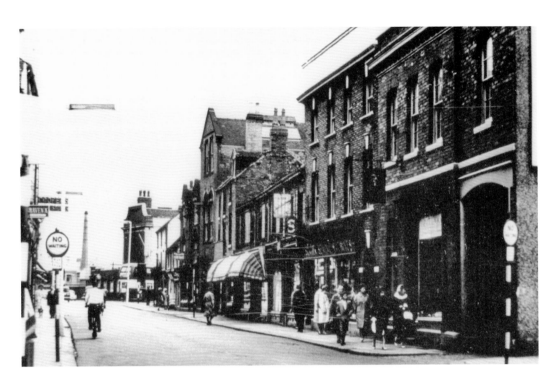

Three Queens Hotel

The Three Queens Hotel, in the distance, is all that remains today from the first picture. Shops that made way for Bargates, when the traffic was able to turn into Bridge Street, are now a distant memory.

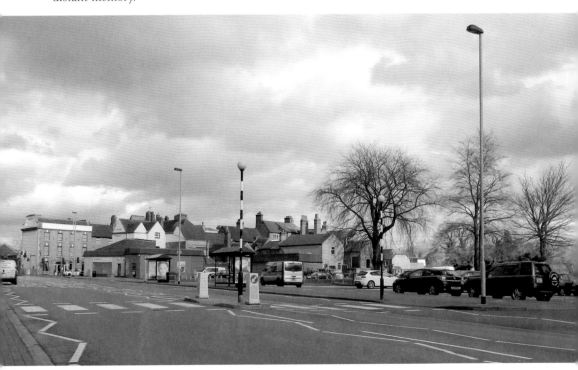

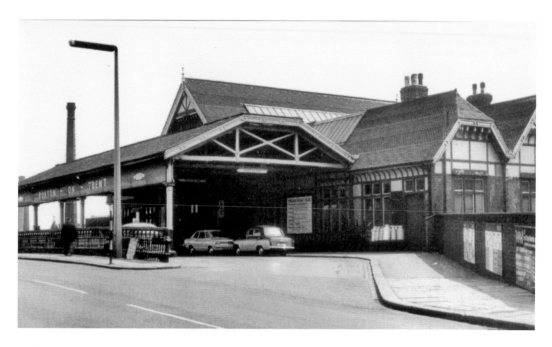

Railway Station
The marvellous frontage to the railway station was demolished in the late 1960s and early 1970s to make way for what is certainly modernisation, but definitely not as pleasing to the eye.

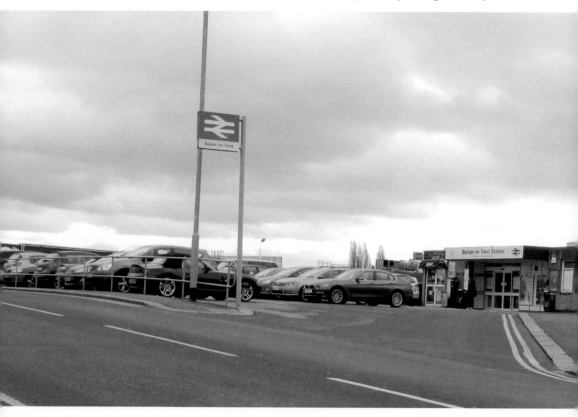

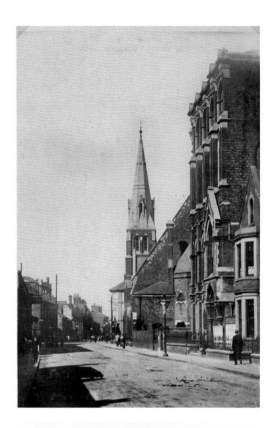

Union Street

As can be seen, the old library building and the Methodist church on the right-hand side of Union Street have made way for an extension to the central area car park. The road also been widened.

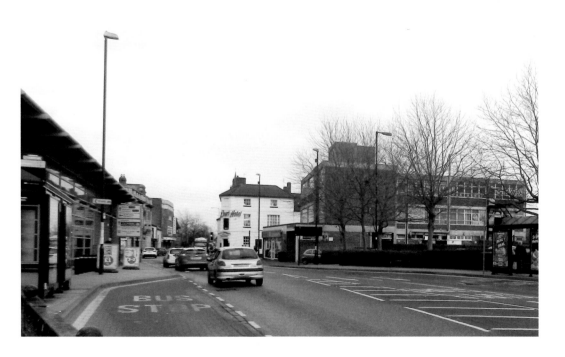

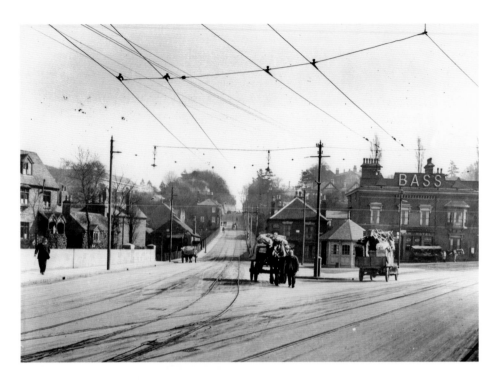

Trams

Taken at the time of the tramway system, there is a clear view of the overhead cables and the track running onto the bridge in the photograph above. The junction has had many changes in order to deal with the heavy traffic flow. Swan Hotel is now apartments and the route up Bearward Hill is controlled by traffic lights.

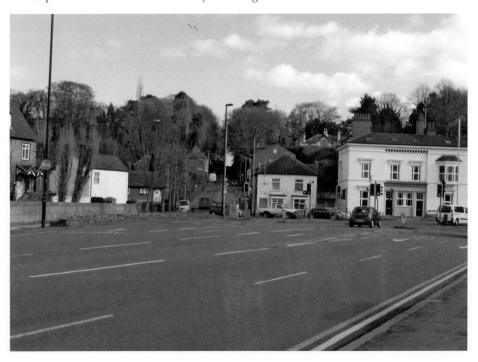

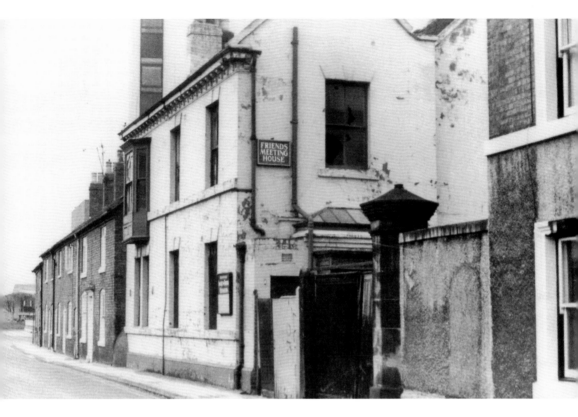

Leopard Inn

The gate pillar of the Leopard Inn is all that remains of the properties that stood in Abbey Street. Terraced cottages, the Friends Meeting House and, in the distance, the Marquis of Anglesey public house, have all gone.

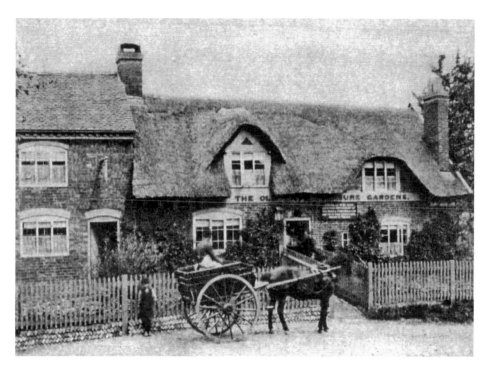

The Old Gate

The Old Gate Pleasure Gardens at Winshill, pictured above in 1880, was also known as the Old Gate Inn. It has been lovingly restored over the last few years; the thatched roof has been replaced by a slate roof, the interior has been modernised, and it is now a private dwelling.

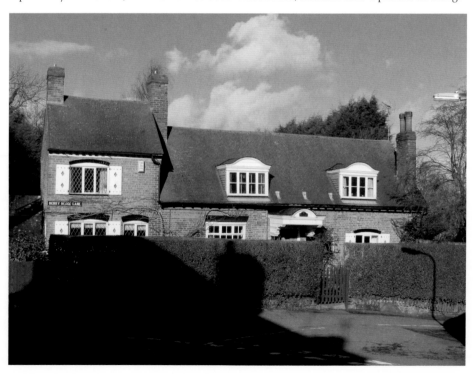

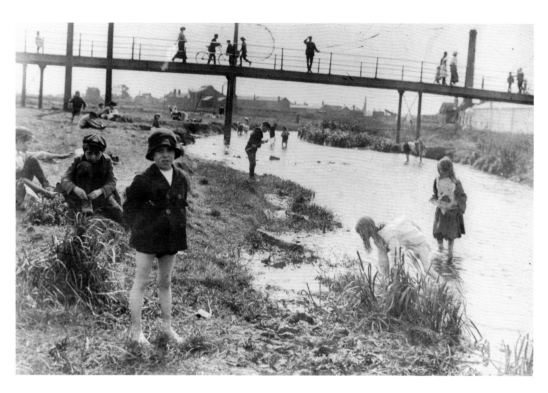

Silver Way

Silver Way was used as a popular bathing and paddling venue well into the 1960s. Now silted up, the only part still recognisable is the viaduct.

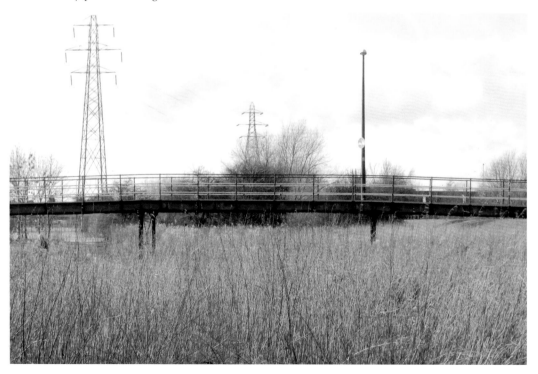

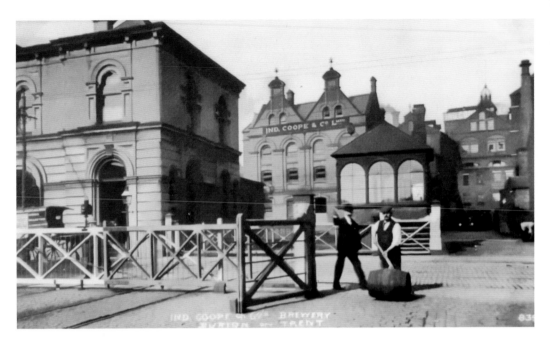

Allsopp's Level Crossing
Allsopp's level crossing in Station Street can be seen in this view from Grant's yard. The internal track was removed in 1965 and the large building to the left is now the Guild Hall.

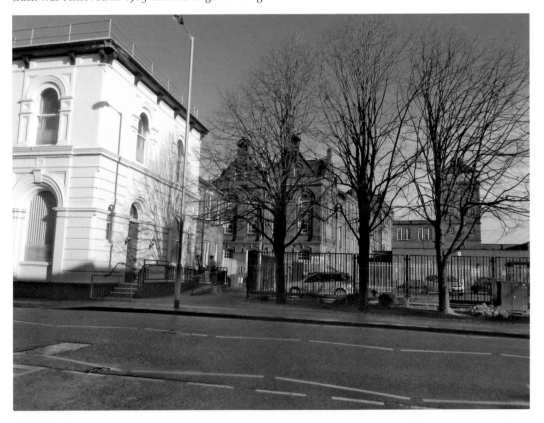

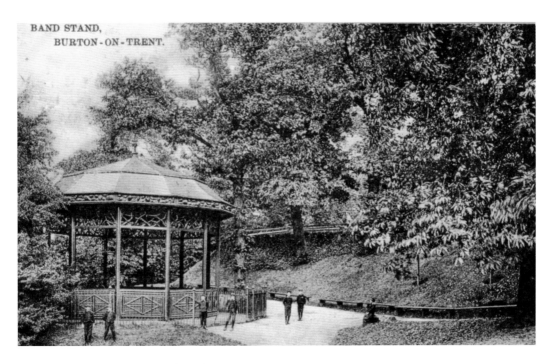

BAND STAND,
BURTON-ON-TRENT.

Stapenhill Gardens Bandstand
Stapenhill Gardens bandstand and surrounding area are now greatly altered. Seating has replaced the actual bandstand and the pathways have been realigned around it.

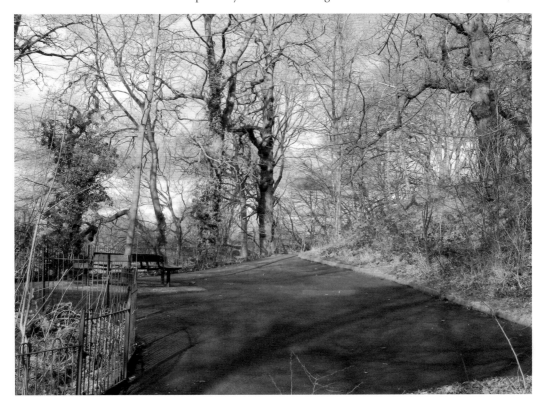

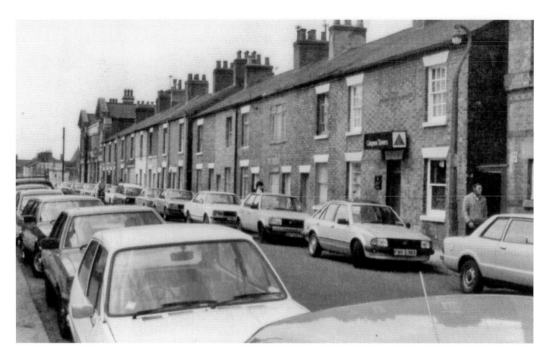

Coopers Tavern

Coopers Tavern in Cross Street stands out more nowadays than it did in the earlier photograph. Immensely popular with the clientele, it is still regarded by many as a model of how a public house should be.

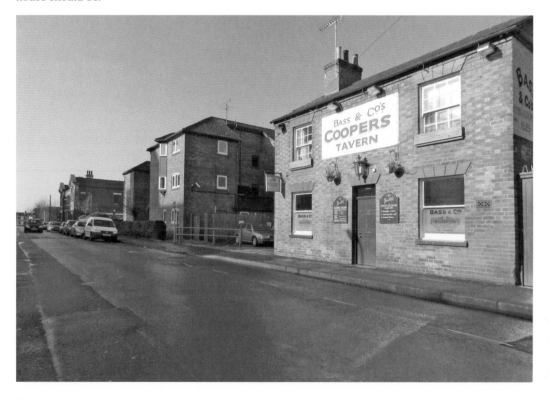

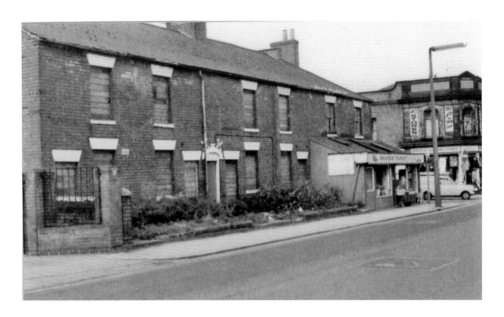

Station Street

Bass cottages and Drapers Florist's shop in Station Street, leading up to Cross Street corner, were all demolished in the 1980s. At one time, the Bass Barrell fountain was sited on this corner before being relocated.

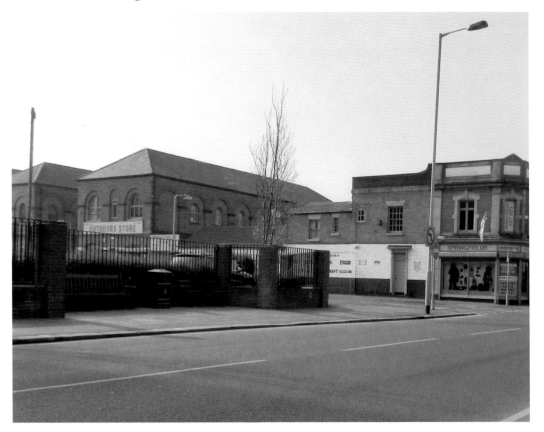

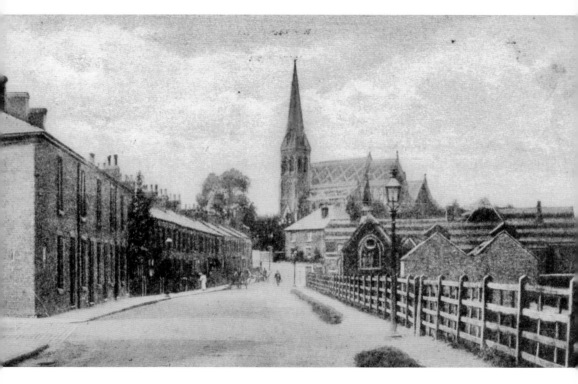

Hawfield Lane, Winshill
All that remains from the early picture is Winshill church and the large house directly in front of it. Both sides of the road have been vastly improved.

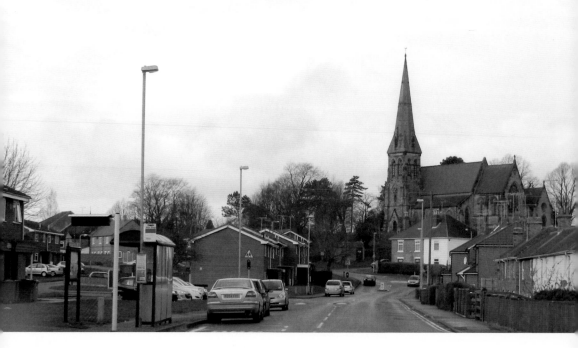

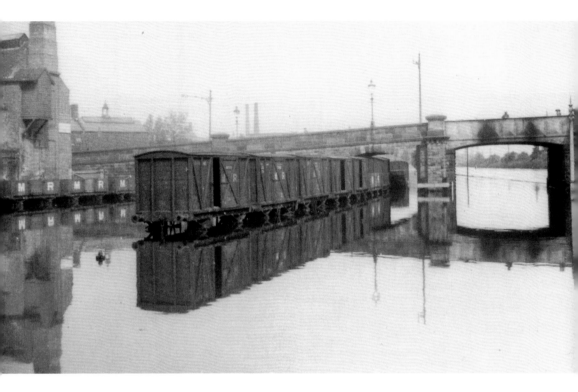

Hay Wharf

Hay Wharf is totally unrecognisable nowadays from when brewery locomotives frequented the area. The ground has been significantly built up on the route of the railway lines.

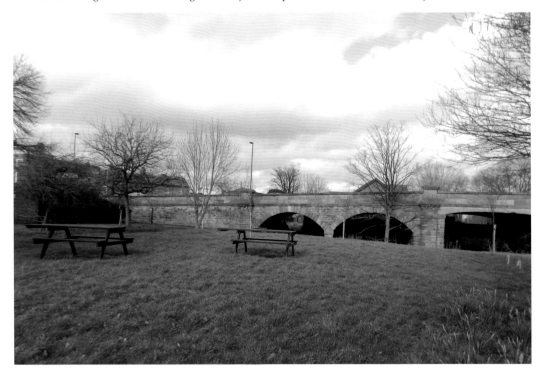

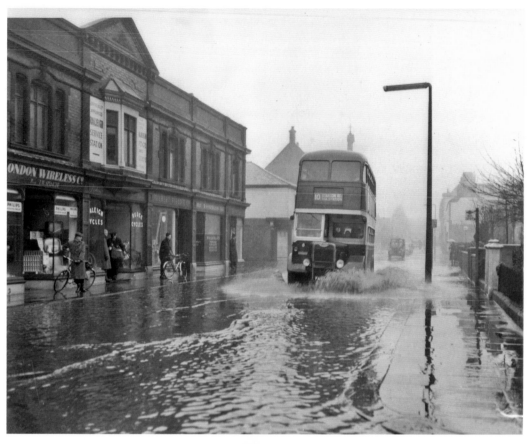

Station Street/Milton Street Corner
Apart from changing usage, the shops on the left have not altered since the first picture was taken, with the Corporation bus making its way through the floods in the mid-1960s.

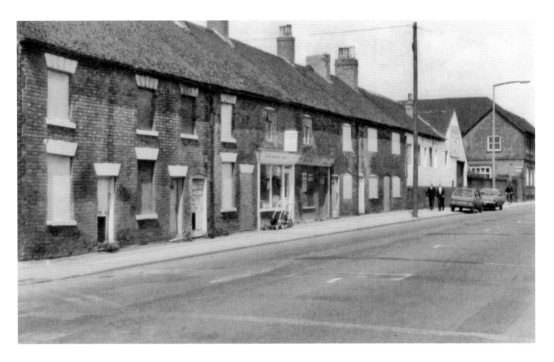

Horninglow Street

Horninglow Street, from opposite the junction with Hawkins Lane to the tall building of Geo. Hodges & Son Ltd offices, was all demolished in the late 1980s. Cottages, shops and the white-painted building of J. Levers are all gone.

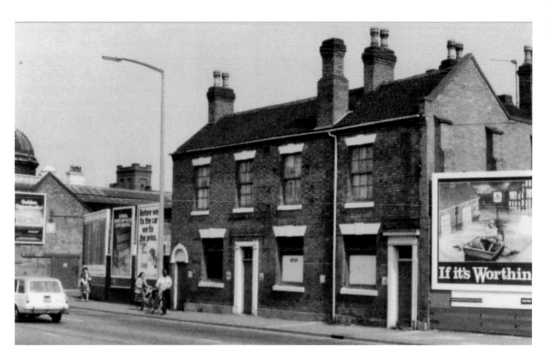

Horninglow Street
Nos 160/161 Horninglow Street (the former Rising Sun public house in the older picture) made way for the new police station and magistrate's court buildings in the 1980s.

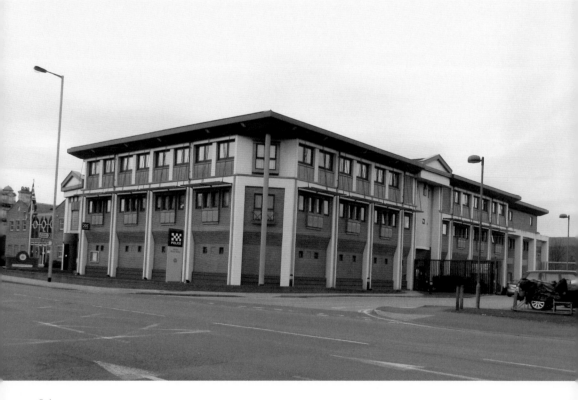

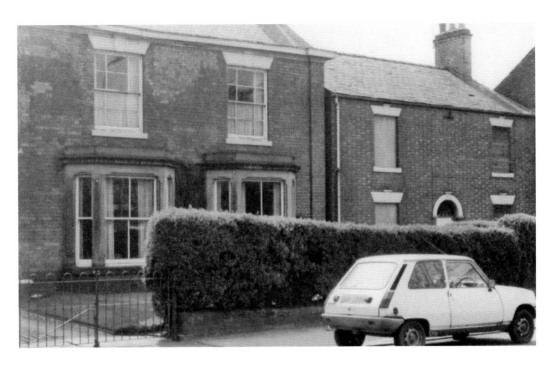

Guild Street

In Guild Street, Frankie & Benny's restaurant now stands on the location of No. 63, the large house on the left, and Nos 64 and 65, the double-fronted property to the right. The former properties were all demolished in the 1980s.

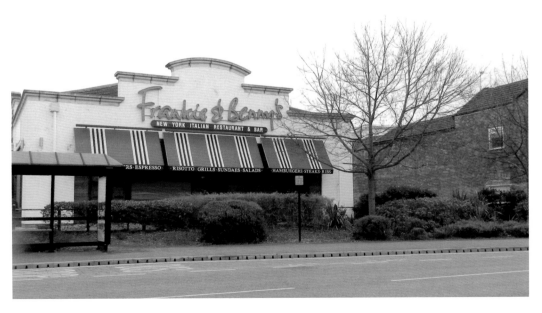

St Peters Street

The widening of St Peters Street in Stapenhill for the approach to the second river crossing (St Peters Bridge) necessitated the demolition of the large corner property opposite Spring Terrace Road junction.

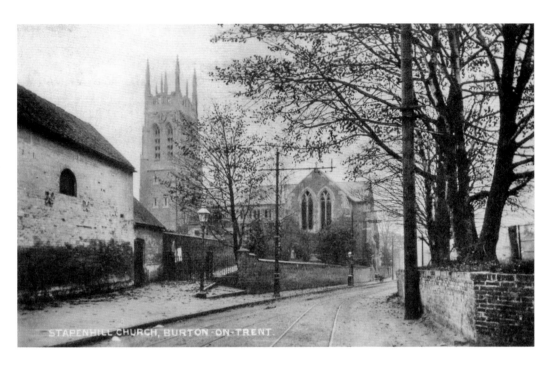

STAPENHILL CHURCH, BURTON-ON-TRENT.

Stapenhill Road

Until the 1930s, No. 90 Stapenhill Road stood adjacent to Stapenhill church. The ground it occupied is now a roadway, required to manage the vast improvements to the road network and increased traffic at this junction.

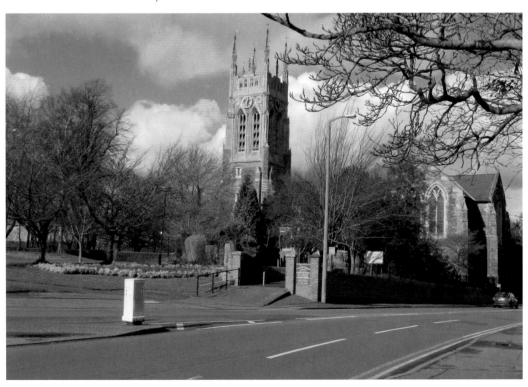

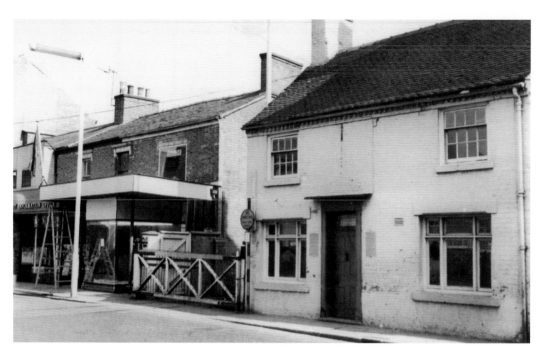

Worthington Way

Worthington Way is the site of the Mayors Arms public house and Worthingtons railway crossing in the earlier photograph. Initially a town centre car park, it has since been redeveloped to include the entrance to Burton Place Shopping Centre and the route through to High Street.

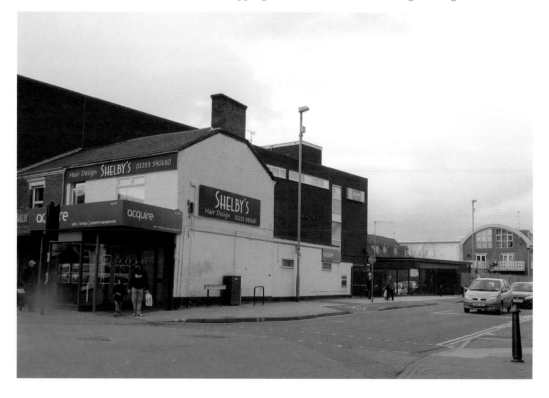

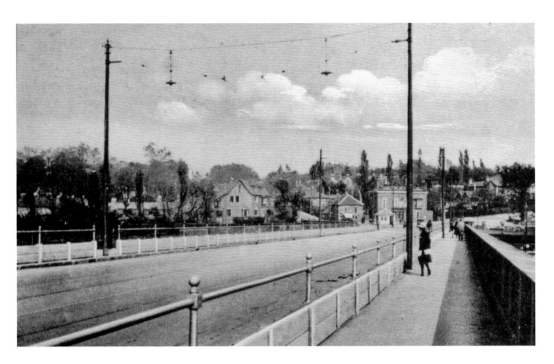

Trent Bridge

The bridge, which was known as Trent Bridge at the time of the 1920s image, is today titled Burton Bridge. Splashboards installed at the time disappeared during the Second World War, along with the iron handrails, which were removed to be melted down in order to aid the war effort.

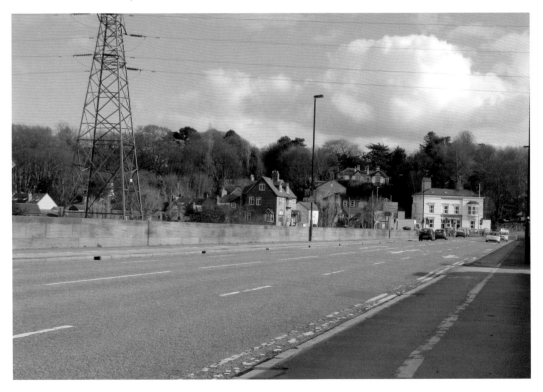

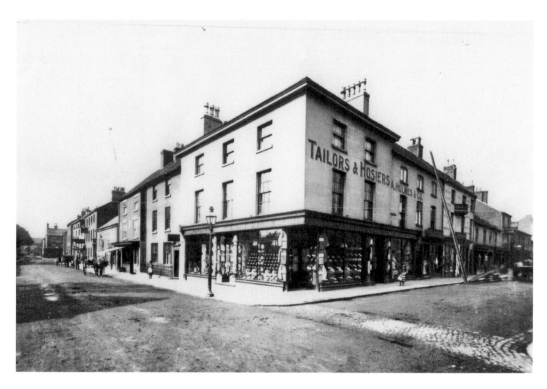

Lichfield Street/New Street Corner

The properties on Lichfield Street/New Street corner have facilitated many different trades since the earlier image was taken. The large corner building has, in its time, been a tailor's and draper's, a Boots chemist, Norman's Musical Supplies and, in its current incarnation, an estate agent's.

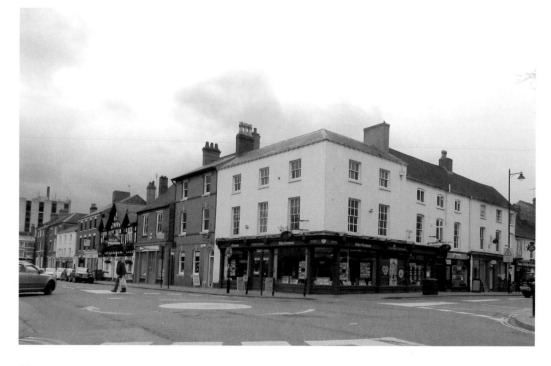

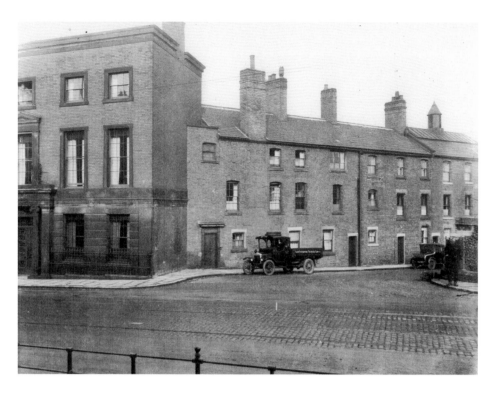

Trent Terrace

Trent Terrace is located at the town end of Burton Bridge. The property on the far right, with the glass skylight, initially housed a private museum. Along with the adjoining houses and the large Trent House, it has now formed part of the Three Queens Hotel complex.

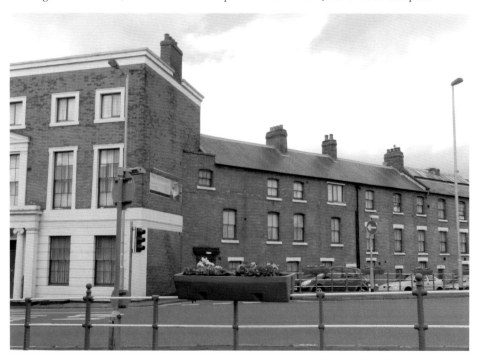

Burton upon Trent Memories

Terry Garner

Burton upon Trent Memories offers a nostalgic look back at the
town's past through a series of postcards, photographs, receipts and
adverts from the author's own collection

978 1 4456 3458 6
128 pages

Stafford Through Time

Anthony Poulton-Smith

This fascinating selection of photographs traces some of the many ways in which Stafford has changed and developed over the last century.

978 1 4456 0953 9

96 pages, full colour